IMAGES
*of America*

# PRINEVILLE

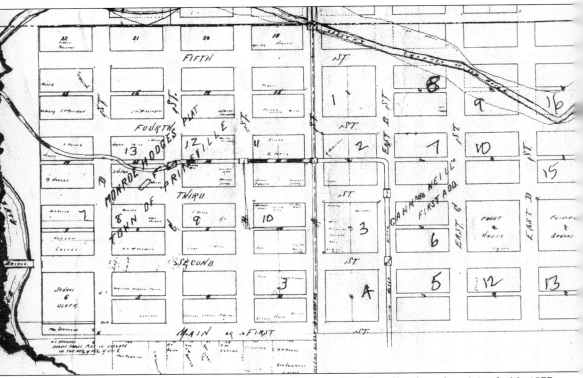

This 1894 map shows the layout of the city of Prineville, officially platted on March 28, 1877. Monroe Hodges had purchased Barney Prine's homestead claim along the banks of the Crooked River in 1871, and Hodges's property became the site of Prineville. The north-south streets were identified with letters, in alphabetical order, and the east-west streets were numbered. Main Street was identified as First Street on this map.

ON THE COVER: Prior to the turn of the 20th century, saloons and harness shops were major businesses in Prineville. This posed photograph shows Prineville harness maker Charles Perrin holding a saddle in front of a harness shop. (Courtesy of Bowman Museum.)

IMAGES
*of America*

# PRINEVILLE

Steve Lent

ARCADIA
PUBLISHING

Published by Arcadia Publishing
Charleston SC, Chicago IL, Portsmouth NH, San Francisco CA

Printed in the United States of America

Library of Congress Catalog Card Number: 2006933259

For all general information contact Arcadia Publishing at:
Telephone 843-853-2070
Fax 843-853-0044
E-mail sales@arcadiapublishing.com
For customer service and orders:
Toll-Free 1-888-313-2665

Visit us on the Internet at www.arcadiapublishing.com

To my mother, Mabel Lent, always supportive
and a continuing inspiration

# CONTENTS

# ACKNOWLEDGMENTS

A book of this nature requires the assistance of many people. The board of the Crook County Historical Society has provided the guidance to preserve the history of the local area, and Bowman Museum director, Gordon Gillespie, has given encouragement and the gift of time to put the pieces together. The Bowman Museum's photograph collection, extensive research library, and archival records have been invaluable in compiling the photographic history of Prineville. Unless otherwise noted, all images appearing in this book have been graciously provided by the Bowman Museum in Prineville.

I also would like to thank my editor at Arcadia Publishing, Julie Albright, for keeping me on track and easing the anxiety of completing the puzzle in proper order. At times, it all seemed overwhelming, but expert advice and a guiding hand has led to the successful conclusion of this project.

Hundreds of photographs have been searched trying to find the right combination to tell the story of Prineville, and local author Keith Snyder has been very helpful in identification of key images for the telling of the story. Local historian Frances Juris continually amazes with her knowledge and willingness to assist in preserving the heritage of Central Oregon. Her advice is highly cherished.

My wife, Barbara, and children Jonathan and Allison have long been supportive and encouraging, and this book could not have been completed without their understanding.

# INTRODUCTION

The Central Oregon region was mostly bypassed in the rush to settle the Willamette Valley. Major mining activity never occurred, and as a result, settlement came relatively late to the High Desert east of the Cascades. The lush grasslands of the region beckoned the first settlers to the area in 1867, and they came to graze livestock near the confluence of Ochoco Creek and Mill Creek. Soon other settlers arrived, and in 1868, Frances Barney Prine became one of the first to settle along the banks of Crooked River in the valley nestled between rimrocks. He established a primitive blacksmith shop and dispensed liquor from the back of his shop. The post office of Prine was established in 1871. Prine sold his holdings that year to Monroe Hodges for $25 and a packhorse. The post office name was changed to Prineville in 1872. Hodges had visions of grandeur for the young community, and after he "proved up" on his homestead claim, he began to plat a community with streets wide enough to turn a wagon around.

At this time, all of Central Oregon was part of Wasco County, with the county seat located in The Dalles. Hodges rode to The Dalles, and the town-site plat was filed for Prineville on March 28, 1877. He had lots partitioned on his property within the town limits and began selling them for $10 each. To help promote business in the new community, he donated some lots. Soon the community began to grow and a flour mill, planing mill, and merchandise store were established. Monroe had earlier established a hotel, and the community became the major commercial center for Central Oregon.

Prineville emerged as the focal point for growth on one of the last frontiers in Oregon. Stock raising was the major business enterprise, and most businesses catered to local ranchers. Freight and stage lines began servicing Central Oregon through Prineville, and it was once said that "all roads lead to Prineville." The young community began to bustle with activity, but it was located a long distance from county government and law enforcement authorities.

Violence soon began to arise on the rugged frontier. In 1882, a local land dispute erupted into a double murder north of Prineville. The culprit was captured, but because there was no jail in Prineville, he was held in a local hotel waiting for justice in The Dalles. A group of local citizens decided that justice could not wait and formed the Committee of Vigilance, more commonly known as the Vigilantes. The hotel was stormed by masked riders, and the prisoner was shot and killed. A hired man of the victim was considered guilty by association. Found in a boardinghouse, a rope was thrown around him, and he was dragged through the streets to a wooden bridge on Crooked River and hanged. The rule of the Vigilantes had begun.

The violence of the frontier created concern, and local legislators managed to pass legislation to establish a new county in Central Oregon so government would be more locally based. Crook County, named for Gen. George Crook, was created out of Wasco County in October 1882, and Prineville was selected as the county seat. The first election for the new county was held in 1884, and with the establishment of an elected government, the Vigilantes began to be forced out of business.

Prineville began to boom as the major community between The Dalles and Lakeview; it was the only sizeable community in Central Oregon. More businesses were established to cater to the growing population. A new wooden courthouse was built in 1885, and justice was brought to the wild frontier. Further violence later erupted between sheep men and cattlemen, which lasted into the early years of the 20th century.

After the turn of the 20th century, a homestead boom came to Central Oregon, and Prineville served as the base for hundreds of homesteaders trying to find their piece of paradise. The homesteaders found the harsh desert to be a difficult place for their farming enterprise, though, and many soon became disillusioned and abandoned their claims.

The Hill and Harriman Railroads began the last major railroad war in 1910 and fought their way up the Deschutes River to Central Oregon. Unfortunately for Prineville, the rail lines bypassed the major community in the region. Soon upstart communities such as Bend, Redmond, and Madras began to grow with the arrival of the railroad. A grand new stone courthouse was built in Prineville in 1909, and an outcry from the newly developing communities along the railroad led to petitions to form new counties. Jefferson County was created out of Crook in 1914, with Madras serving as the county seat, and Deschutes County was carved from Crook County in 1916. Bend became its county seat. The once huge Crook County was diminished to its current size. The communities along the railroad soon became the new commercial centers for Central Oregon.

The residents of Prineville, concerned that the community would become a ghost town if it did not have a connection to the railroad, passed bond issues, and in 1918, a city-owned railroad was built to the main rail line just north of Redmond. The new railroad provided a rail market for livestock and crops, but industry still did not arrive in Prineville. The rail line floundered for several years until the lumber industry arrived in the 1930s, and it began to boom. Because there were plentiful ponderosa-pine forests in the surrounding region, several large mill operations were established in the community. The railroad provided a means to get lumber to a large market. By the end of World War II, Prineville was once again a booming community, with plentiful jobs in the lumber and logging industry. The lumber industry continued until the 1970s, then gradually began to decline, which caused the railroad to face some hard times. However, it managed to continue operations.

Eventually all lumber-producing mills left the community, but a rising new industry was established in 1952 by a young entrepreneur named Les Schwab, who had grand visions of developing a large tire operation. He started his first store in Prineville, and through the years, it has grown to be one of the largest independent tire businesses in the Untied States, with the base of operations remaining in Prineville. As the mills left the scene, Les Schwab Tires became one of the main employers of the community.

The community has passed through booms and times of hardship, but it remains as the first community established in Central Oregon. This book photographically chronicles the emergence of Prineville from a small frontier outpost to a boomtown and the emergence of a lovely community beneath the rimrocks.

# One

# THE EARLY
# SETTLEMENT YEARS

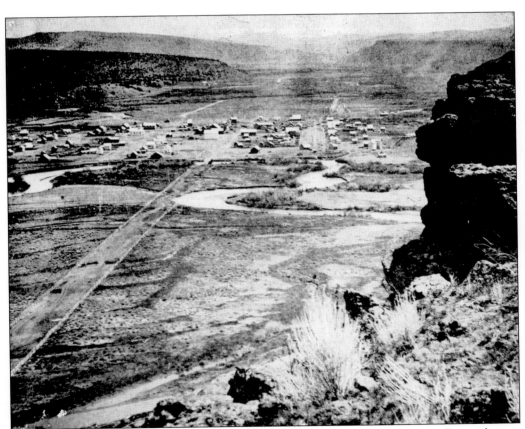

The first known image of Prineville, taken from the overlook known as Viewpoint Rimrock, west of Crooked River Valley, looks east in 1881. The Crooked River flowed through what is now the center of the community and changed its course frequently due to flooding. The roadway coming into town from the lower left is Second Street, which was the main street into town.

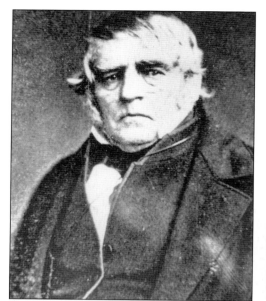 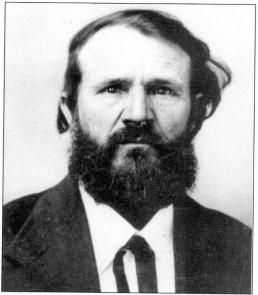

The first known non-Native American to visit the future site of Prineville was Peter Skene Ogden (left), a fur-brigade leader of the Hudson's Bay Company. He passed through the Crooked River Valley in December 1825 while heading the Snake River Expedition in search of beavers. He had a trapping party of nearly 100 that included Native American wives and children of the trappers. Elisha Barnes (right) came from the Willamette Valley to the Ochoco country just east of the future site of Prineville in 1866. He observed the magnificent pasture grasslands and returned to the Willamette Valley to encourage friends to join him in settling the country the following year. The returning party was the first settlers in Central Oregon. Barnes was later elected the first mayor of Prineville.

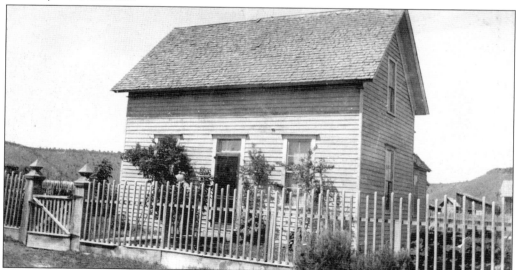

Elisha Barnes first settled on land just east of current Prineville but later lost his holdings to the right-of-way grant for the Willamette Valley and Cascade Mountain Wagon Road. He bitterly protested the loss of his land because the road was never actually built. He then constructed a house in Prineville where he and his family lived. The house is still standing.

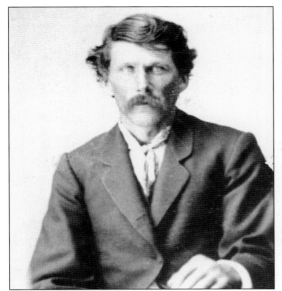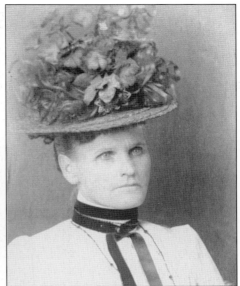

Francis Barnett "Barney" Prine (left) began to feel crowded in the Willamette Valley in 1868, and his pioneering spirit brought him to the Crooked River Valley. Prine built a log cabin, which he used as a living quarters, and established a crude blacksmith shop from which he dispensed spirits. His business became the center of trade for new settlers. He sold his business to Monroe Hodges in 1871, and the family later moved to eastern Oregon. Barney Prine married Elizabeth "Eliza" Sylvester (right) in 1867 just before coming to Central Oregon. She accompanied him to the Crooked River Valley and gave birth to their first son in 1869. She was among the first white women to come to Central Oregon. Several years later, she divorced Prine and married his nephew.

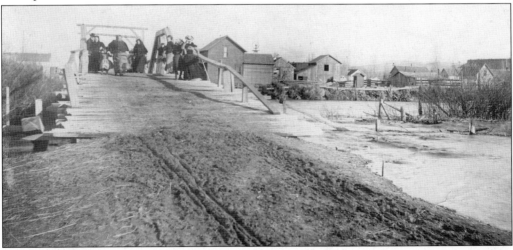

The first bridge across the Crooked River, which flowed through what is now the center of the community, was constructed around 1877 on the western edge of Prineville on west Second Street. The bridge, built of heavy timbers, was known as the "wooden bridge." It was later the site of one of the early violent actions in frontier Prineville when W. H. Harrison was dragged behind a horse through the streets by the Vigilantes and hanged from the bridge in 1882. This photograph was taken around 1885.

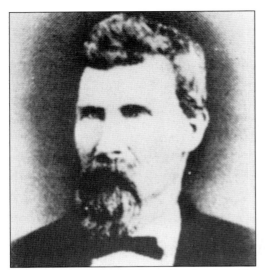

Monroe Hodges (left) followed his brother Alexander to the Crooked River Valley in 1871, where he met Barney Prine, discovered that Prine was ready to move on, and purchased Prine's holdings for $25 and his pack mule. He filed a homestead claim of 80 acres in the Crooked River Valley. After proving up on his claim, he platted a town site and filed his plat in The Dalles on March 28, 1877. He decided to name the new town after the post office of Prineville. Rhoda Wilson Hodges (right), the wife of Monroe Hodges, came to the newly settled vicinity of Prineville with him in 1871. Married since 1855, they had five children before moving to Central Oregon. She often was the hostess for social events in her husband's newly created community.

Monroe and Rhoda Hodges constructed a house in the new section of Prineville on Second and Deer Streets. They lived in the house for many years, and for a long time, it was one of the historical homes in the community. Here granddaughter Dolly Hodges Fessler stands in front of the house. It was demolished in the late 1950s to make room for a parking lot.

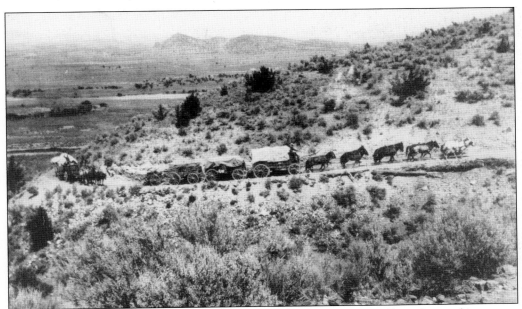

The Old North Grade Road was located on the western edge of Prineville and wound its way up through the rimrock. It was part of The Dalles to Silver Lake Road that passed through Prineville and was located just behind the current Les Schwab Tire Production Plant. The road, the first to directly leave Prineville to the west, was steep and narrow and was the site of many accidents for freight wagons and stagecoaches. The road is now used as a trail path.

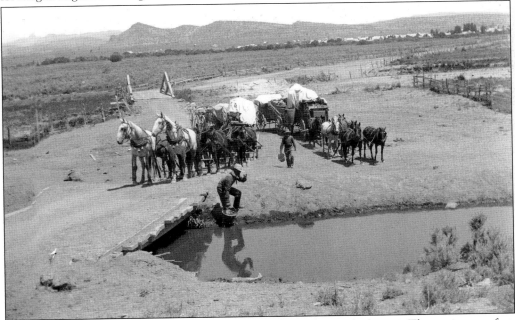

In this 1890 photograph, teamsters are drafting buckets of water for horses. The teamsters often stopped at the bottom before making the ascent to the top of the Old North Grade Road. People's Ditch was constructed for irrigation lower down the Crooked River and was a good last watering spot for animals.

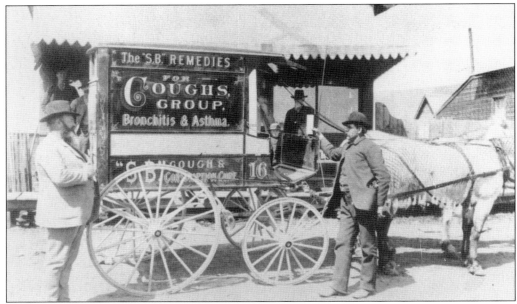

Larkin Vanderpool, the first doctor in Prineville, was a self-educated physician, and because of a shortage of doctors in the Oregon country, he was allowed to practice medicine. He came to Prineville in 1869 and served the community as a doctor. He is pictured in the left of the photograph selling his "famous remedies" from his traveling drugstore. He and his family moved to the Dufur vicinity in 1883 where he became the first doctor in that community.

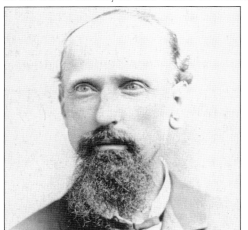 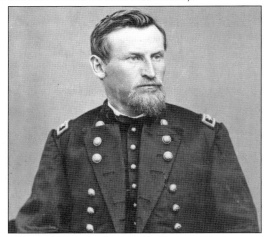

Benjamin Franklin "B. F." Nichols (left) came to Central Oregon from Polk County, Oregon, in 1878. He established the first drugstore in Prineville and soon became involved in local affairs. He was elected to represent the Prineville District of southern Wasco County in the Oregon State Legislature in 1882. His legislation created a new county out of southern Wasco County in October 1882—Crook County. Nichols became known as the "Father of Crook County," and Prineville was chosen as the county seat. Crook County was named for Gen. George Crook (right), who had spent the early part of his military career in Oregon before the Civil War. During the Civil War, he rose to the rank of brigadier general. After the war, he returned to the Pacific Northwest and became commander of the Department of the Columbia. He was involved in Native American skirmishes in the Oregon country for several years.

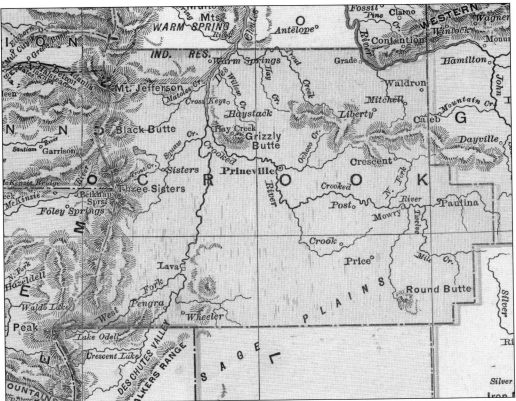

Newly created Crook County encompassed a huge area of Central Oregon. Prineville was the major community in the county, and it was centrally located. Note that Bend, Redmond, and Madras are not identified on the map. Outlying early settlements utilized Prineville as the main business center, and it soon became the political center of the county as well.

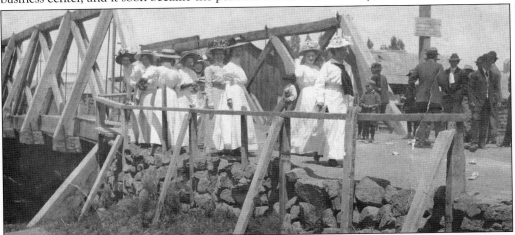

The Crooked River Bridge was often the center of community activities; it connected parts of the community on different sides of the river. This wedding celebration in 1895 gives a sense of community as women and men dress up in their best clothes to celebrate. The women are gathered on one side of the bridge and the men and children on the other.

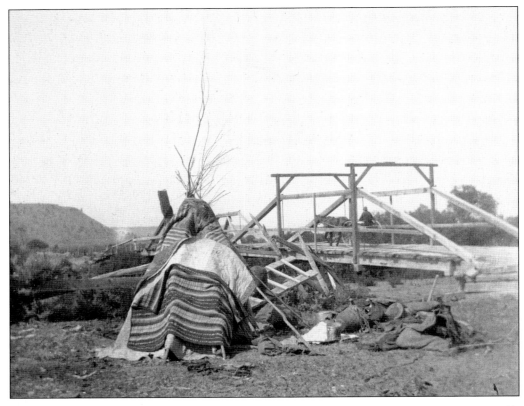

Tribal members living on the Warm Springs Indian Reservation frequently passed near Prineville en route to fishing sites or root-gathering locations. Often they set up camp on the outskirts of Prineville. Occasionally tribal members came seeking work. The camps in these 1895 photographs were located just west of the Crooked River Bridge on the outer limits of Prineville. Town members often came by to talk with the camping Native Americans.

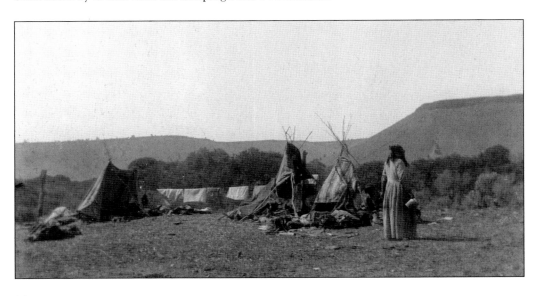

The Jackson House or Prineville Hotel was located on Third and Main Streets. The Vigilante era of Prineville began in this hotel in 1882, when masked riders rode in and shot and killed Lucius Langdon, who was being held for the murder of two men near Grizzly Mountain north of town. Because there was no jail in the town at that time, the prisoner was housed in the hotel. The building was used as a hotel until 1905, when a new stone structure was built at the site.

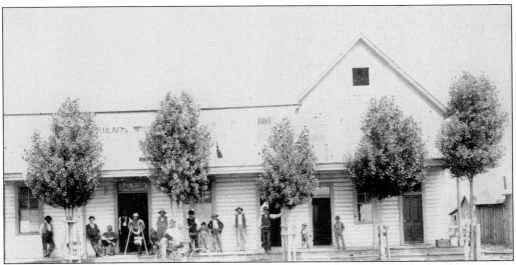

The Occidental Hotel was located at the southwest corner of Second and Main Streets. It was the original site of Monroe Hodges's first hotel, and the building was added onto in later years. Hodges later sold the hotel to William Circles, and the name changed to the Occidental. The hotel burned on the night of November 10, 1883, and the fire destroyed other businesses nearby.

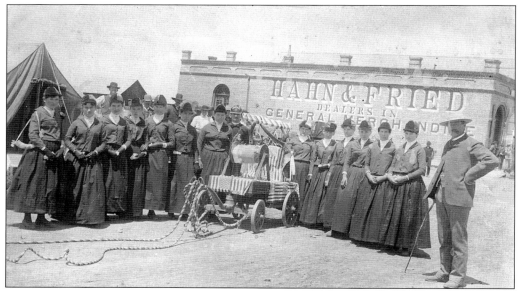

Frequent and disastrous fires in the young community resulted in local citizens financing the purchase of a new hand-drawn fire pump in 1881. The machine could be operated with two to eight men, and the box carried 66 gallons of water. The pump cost $180 and was shipped from New York to Portland via Cape Horn and then by barge up the Columbia River to The Dalles, where it was finally freighted by wagon to Prineville. The original fire pump is still housed at the Prineville Fire Department.

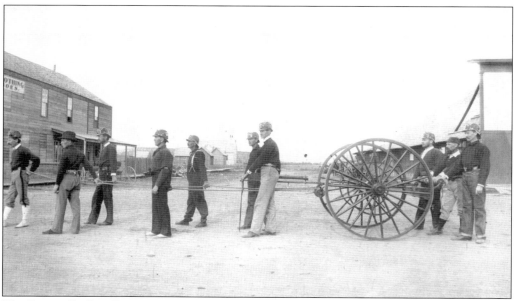

The Prineville Fire Department was established after the purchase of the first fire pump on January 30, 1884, according to the minutes of an early meeting. Twenty-five men signed up as volunteers. There was an initiation fee of $1.50 and monthly dues of 25¢. The budget was supplemented by dances and public donations. Members of the fire department pull a hose cart in this 1890 photograph.

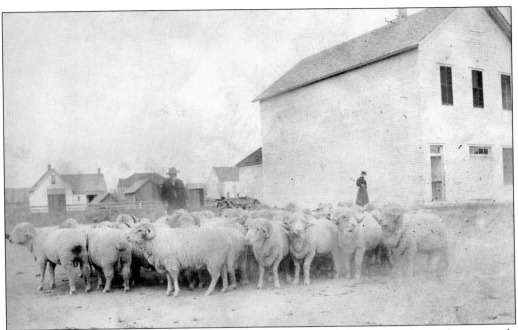

The livestock industry reigned supreme in the early years of Prineville. Livestock commonly were herded through town en route to market or outlying pasture. Sheep are herded through town in this 1900 photograph. Sheep ranching was a huge operation in Central Oregon at the beginning of the 20th century. Cattle operations often competed with sheep for grazing in the plush grasslands of the Ochoco Mountains and High Desert. This led to conflict between sheep and cattle operators.

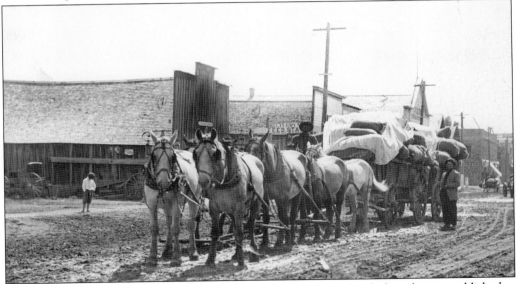

The rise of the sheep industry in Central Oregon led to extensive freight lines being established to carry wool from the surrounding region, first to The Dalles and then Shaniko, when the Columbia Southern Railroad was built there in 1900. Prineville was a major shipping point for wool, and wagons loaded with freight were constantly arriving and departing from the community.

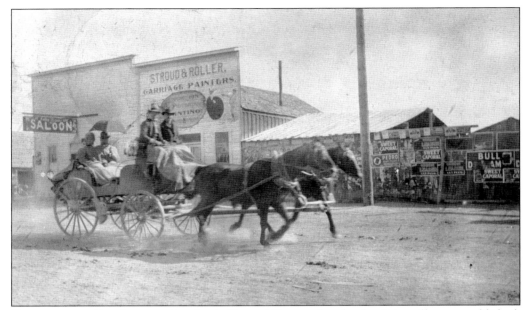

Passenger stage lines began to develop in Central Oregon shortly after Prineville was established. George McIntire "Mack" Cornett established one of the largest stage lines in the northwest and based his operations in Prineville. The first stages arrived from The Dalles, Eugene City, or Sweet Home. After the railroad reached Shaniko in 1900, most stage operations traveled to and from Shaniko.

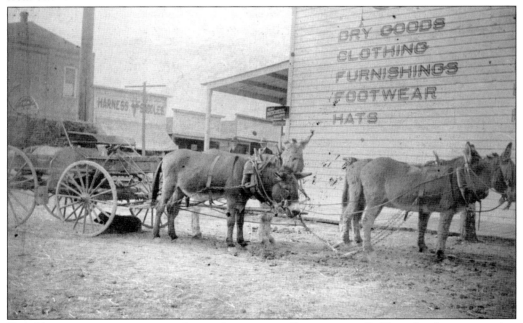

Travel by stage was a strenuous and rugged experience. Stages were pulled by either horses or mules, and roads were very rough. It often took two to three days to travel from Shaniko to Prineville with stage stops at Heisler Station or Hay Creek. Stagecoach mules and a dog take a rest next to the Salomon Store in Prineville around 1895.

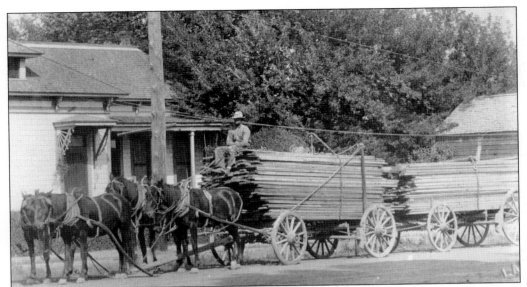

Among the earliest industrial businesses in Central Oregon was the operation of sawmills. It was essential to have lumber to build homes for the growing population, and small mills began operation to supply lumber to local markets in the immediate vicinity of the mill. Prineville was located about 10 miles from the nearest forested region so most of the lumber had to be brought to town from the small mills. A load of lumber is being delivered to Prineville from a Grizzly mill around 1900.

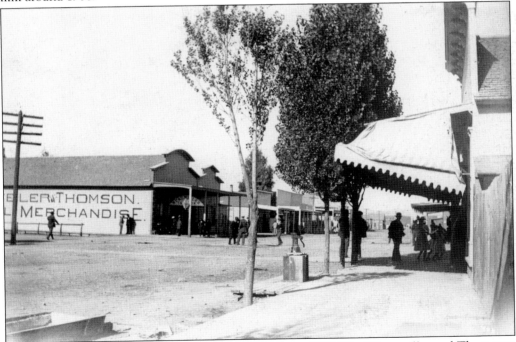

This view is of northwest Main and Third Streets about 1897. The Wurzweiller and Thompson Merchandise Store is located on the west side of the street. Note the old hand pump in the foreground. Water and watering troughs were available for horses and other animals.

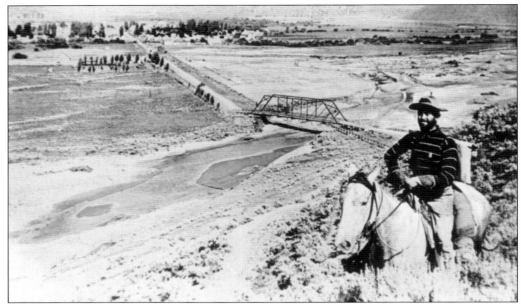

Prince Glaze is astride his horse just west of Prineville in 1911. The steel bridge had been constructed to the west of town and the Crooked River had been diverted to about its present location beneath the rim west of town. Local residents constructed a diversion dam at the beginning of the 20th century to channel the Crooked River further west so land could be utilized for commercial purposes.

In 1885, the first Crook County Courthouse was built on Third and Court Streets in downtown. The two-story wooden structure was the pride and joy of the community. The masonry addition to the left is the first jail. The roof was flat and had handrails so visitors could view the town from the top of the building. It was used until 1908, when construction began on the current stone courthouse. The old courthouse was moved two blocks east to be used as an annex for the high school.

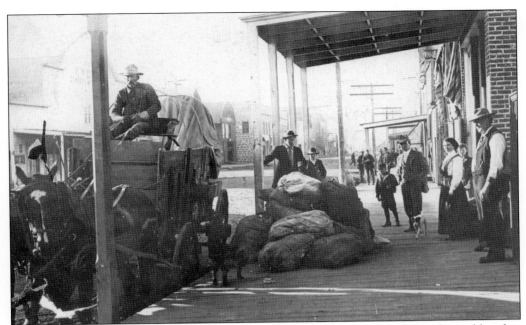

The arrival of freight and stages in Prineville was a big event. Frequently locals would gather around the freight or stage depot to see who or what was arriving. Curious residents gather on northwest Main Street to behold newly arriving freight around 1895.

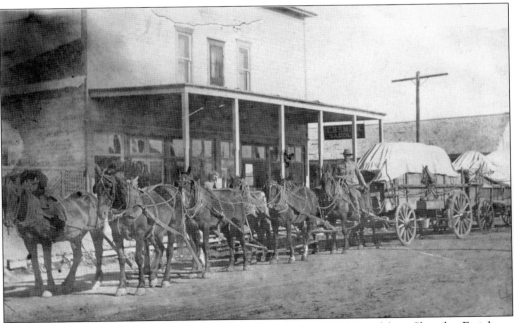

Freight wagons arrive in Prineville about 1900 laden with supplies shipped from Shaniko. Freighters had long hauls carrying freight from The Dalles and Shaniko to Prineville, Silver Lake, and Lakeview. Later wagons went to Farewell Bend, Madras, and Redmond. Most freight first came to Prineville then was reshipped to outlying communities.

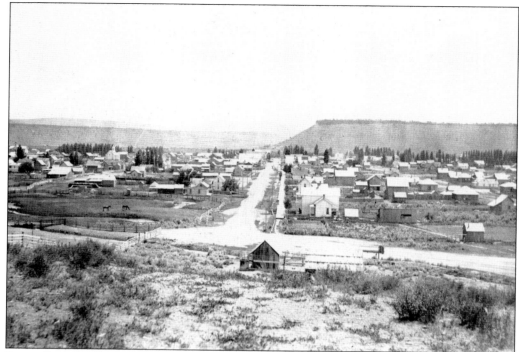

Prineville was a thriving community at the beginning of the 20th century. This view of Main Street looking south shows the expanding city. It boasted wooden sidewalks, some of which can be seen along the street in the middle of the photograph. Streets remained dusty during dry periods and muddy during wet weather. Residences were expanding north and east.

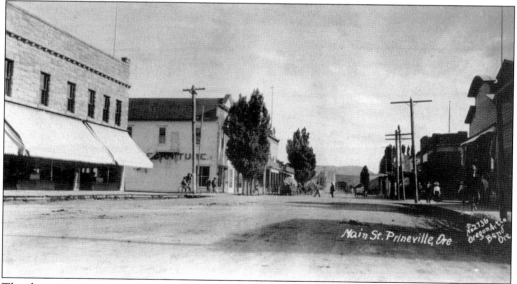

The downtown section of Prineville has a new stone Hotel Prineville to the left in this view of Main Street in 1905. The new stone building of the Prineville Bank is visible in the right middle of the photograph. Wagons line the street as well as telephone and electrical lines. The streets were designed to be wide so freight wagons and stages could turn around.

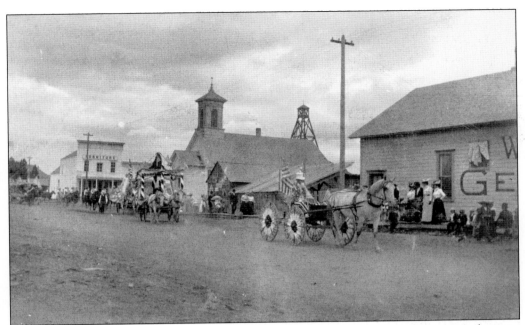

In 1899, an early parade on Third Street in Prineville demonstrates the community's desire to take advantage of moments such as the Fourth of July to celebrate. Lippman Furniture Store is located to the west. The old fire bell tower dominates the skyline behind the old Union Church. The Wurzweiller and Thompson Store is in the foreground.

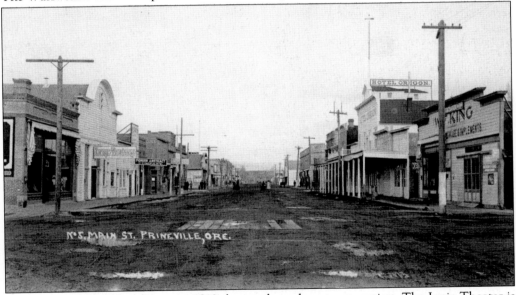

Looking north on Main Street in 1910 shows a busy downtown section. The Lyric Theater is on the left and W. F. King Hardware on the right. The Poindexter Hotel, or Hotel Oregon, is located in the middle right on the east side of Main Street. The streets are muddy after a recent rain. Note the wooden cistern cover in the street. Cisterns were dug to hold water for firefighting and were located at the major intersections in downtown. Running water and hydrants were not yet available.

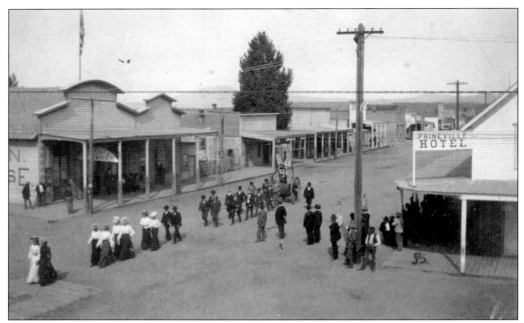

The city joined the nation in mourning the death of Pres. William McKinley in 1901 with a memorial parade, pictured here proceeding south on Main Street at Third Street. Hotel Prineville is to the right, and the Wurzweiller and Thompson Store is to the left. The flag is at half-staff in the background.

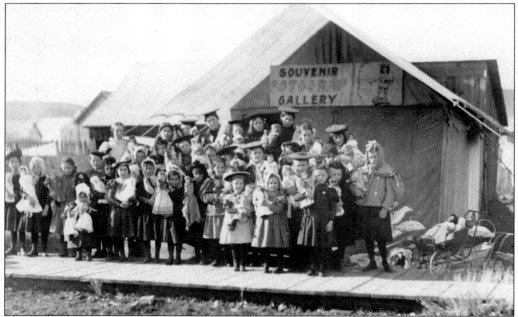

Young schoolchildren celebrate a holiday at a tent set up to provide souvenir photographs. It appears that many young girls arrived to have their photograph taken with their dolls. They are standing on the modern boardwalk in the main section of town. Since entertainment usually meant a special occasion, most children created their own with the toys available to them.

# Two

# ENTREPRENEURSHIP ON THE FRONTIER

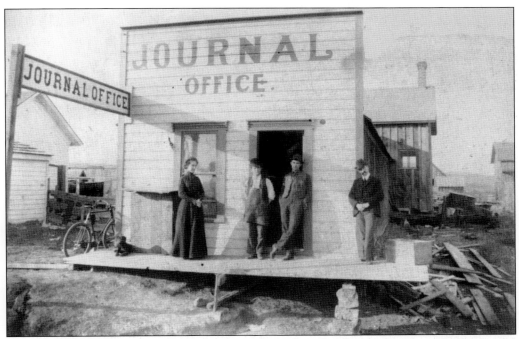

Newspapers were always popular in frontier towns, as residents were desperate for news of the outside world. The first newspaper in Prineville was the *Ochoco Review,* and it was a two- to four-page menagerie of old national news and local happenings. This is the *Crook County Journal* office around 1910. It was located on northeast Main Street near the present site of the *Central Oregonian* newspaper.

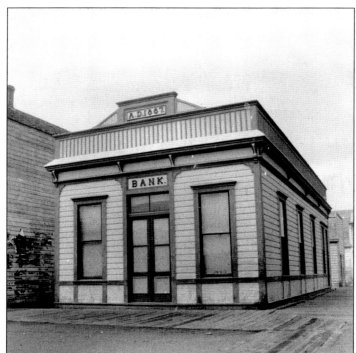

The first bank in Prineville began operations in 1887 and was known as the First National Bank of Prineville. Capital for the bank was invested by local businessmen. The wooden building was located on the southwest corner of Third and Main Streets and served as the bank until a new stone structure was built on the same site in 1906. The wooden building was moved to various locations but is still being utilized.

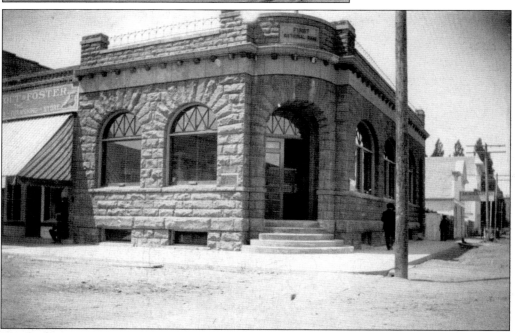

This is the stone structure that replaced the first wooden bank building in 1906. It was made of stone quarried at the basalt rimrock west of town and continued to operate as the First National Bank of Prineville. The building just to the left of the bank is the Foster and Hyde Dry Goods Store, which remains as a historic structure in its original location on the southwest corner of Third and Main Streets.

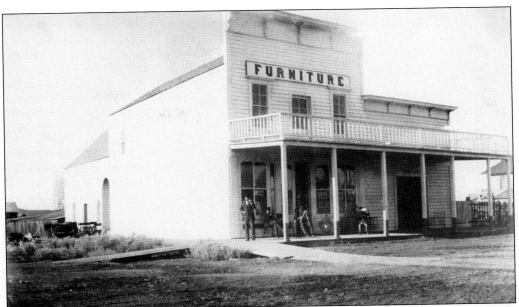

C. C. Mailing first operated a furniture store at the corner of Third and Beaver Streets in 1886. In 1893, he sold his operation to A. H. Lippman, who operated the furniture store as well as an undertaking firm in the building. In 1902, Lippman sold his undertaking business to George Meyer but continued to operate the furniture store.

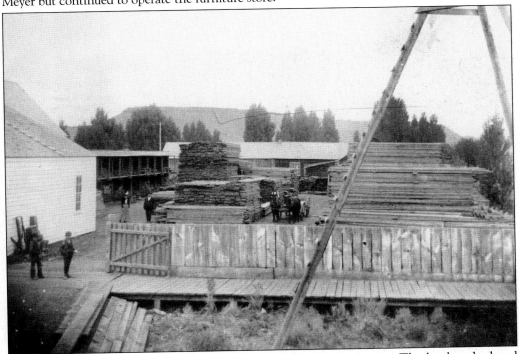

A. H. Lippman also operated a lumberyard behind his furniture store. The lumber shed and carpenter shop are visible in the background. An elaborate wooden sidewalk is located in the foreground. The business continued to operate until Lippman's death in 1916.

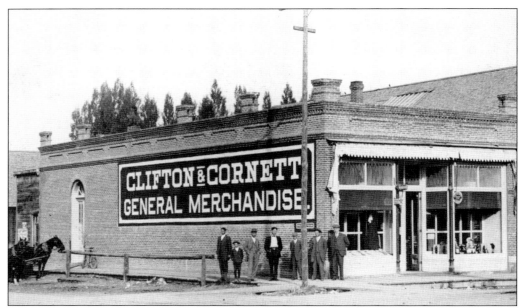

One of the early dry goods stores, located on the northwest corner of Second and Main Streets, was operated by George Cornett and Granville Clifton. The two men purchased the business of R. E. Simpson in 1907 and operated the store as Clifton and Cornett General Merchandise. The structure was the first brick store building in town and was commonly referred to as the "Brick Store."

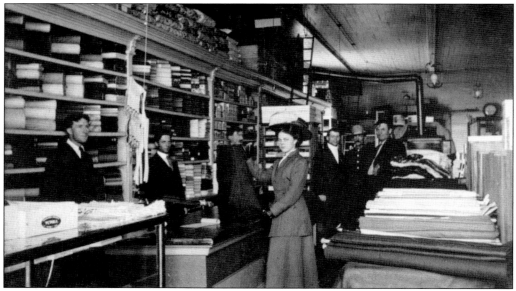

Bolts of cloth and other dry goods are on display in this view of the interior of Clifton and Cornett General Merchandise Store. The clerk on the left is Warren Crooks and the others in photograph are unidentified. The business continued to operate until Clifton sold his interest in the firm to Cornett in 1916, and it operated as Cornett and Company.

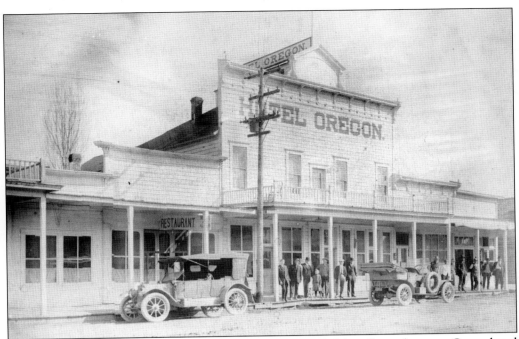

The Poindexter Hotel was located on the east side of south Main Street between Second and Third Streets. Constructed in 1900 by P. B. Poindexter, the hotel was sold to A. A. White in 1910 and renamed the Hotel Oregon. This faded photograph shows the Hotel Oregon about 1912. In a building behind the hotel was the Poindexter Restaurant. The hotel was destroyed by fire in 1917.

The need for hotel space resulted in the old C. C. Mailing home being converted to a hotel known as The Redby in 1900. It was located at the corner of Fourth and B (later Beaver) Streets. Chris and Amanda Cohrs operated the hotel, which was advertised as the "only first class house in town." Room rates ranged from $1.25 to $2.

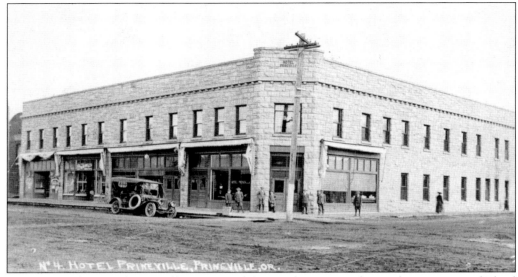

The old wooden Hotel Prineville was moved from its location at the southwest corner of Third and Main Streets in 1905, and a new stone hotel was constructed at the site. Mary McDowell built the new hotel with pink rock quarried from Barnes Butte just north of town. The building was completed in 1906. McDowell thought the building to be fireproof and did not carry any fire insurance. It was destroyed by fire in 1922.

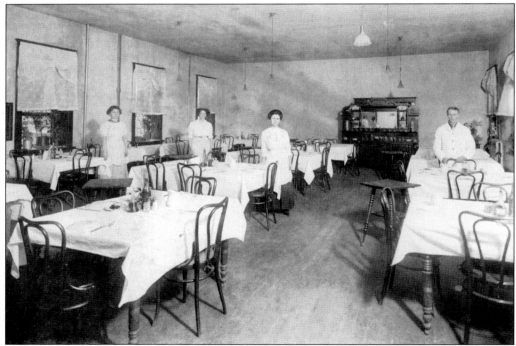

This interior view of the dining room at Hotel Prineville in 1906 shows waiters and waitresses standing in anticipation of providing service to guests. The spacious dining room was located on the ground floor facing Third Street. There also was a bar and card rooms located on the lower floor.

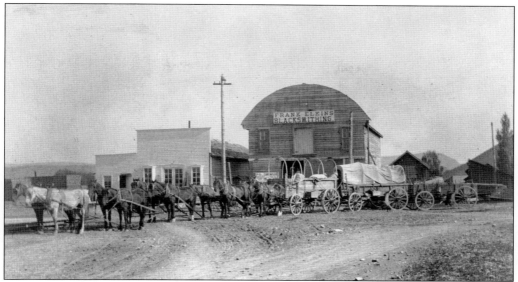

Blacksmith shops were an important part of a frontier town. This is a 1901 view of Frank Elkins South End Blacksmith Shop, located at the then southern end of Main Street on the east side between Third and Fourth Streets. The location of the shop changed several times through the years, but it maintained its South End name.

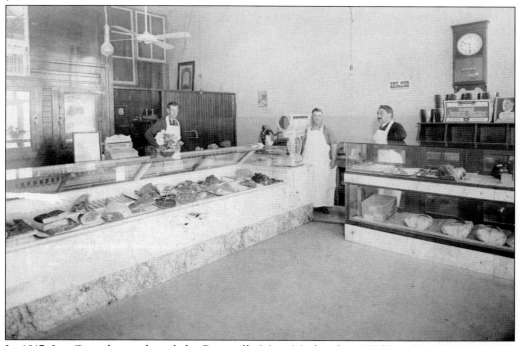

In 1917, Joe Gerardo purchased the Prineville Meat Market from William Davenport. In this nostalgic photograph, Joe Gerardo is standing to the right behind the glass display cases filled with various cuts of meat. Advertisements in 1918 listed a complete line of meats, both smoked and fresh, and fish in season. Fresh berries were also provided in their season. The building was destroyed by fire in 1922.

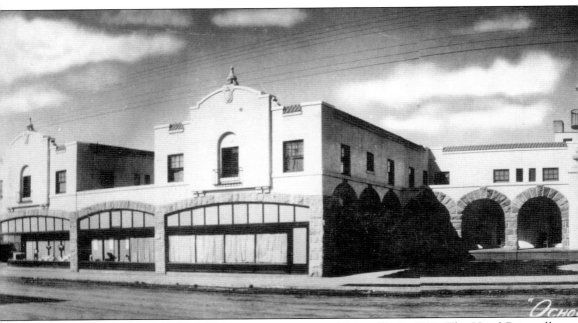

A devastating fire destroyed the downtown section of Prineville in 1922. The Hotel Prineville was ruined, but a new hotel was built on the site at the southwest corner of Third and Main Streets in 1923. A contest was held to determine the name and Ochoco Inn was selected. The Spanish-style building occupied a half-block area and was advertised as one of the finest hotels

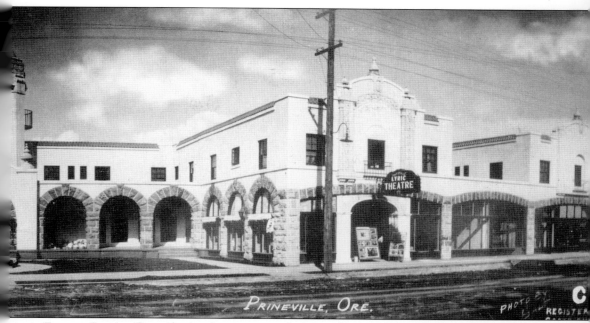

PRINEVILLE, ORE.

in Eastern Oregon. Several other businesses, including a drugstore, theater, dance studio, and a Pacific Power Company office, shared the building space on the ground floor. The upper floors had modern rooms with running water. The hotel featured a full-service dining room and a bar known as The Cinnabar. The magnificent structure was destroyed by fire in 1966.

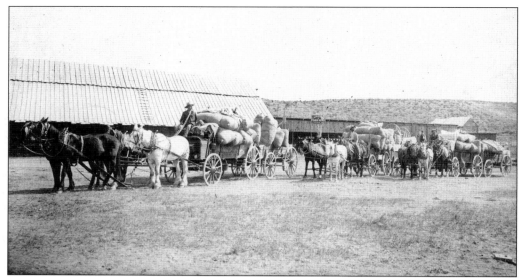

A. "Dad" Kester operated a feed yard on the east side of Main Street, north of Eighth Street. In 1909, he constructed a new shed tall enough to house the largest loads of freight. Freight wagons utilized the feed yard while making stops on the Shaniko–Prineville–Silver Lake route. This photograph shows several freight wagons at Dad Kester's Feed Yard in 1905.

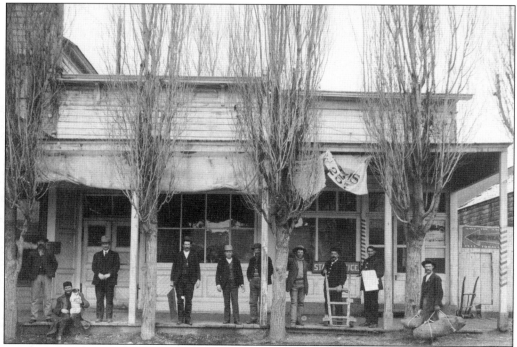

The old Singer Saloon was located on the east side of Main Street near the corner of Second Street. Til Glaze purchased the saloon business in 1878 and later bought the building and property in 1881. A gunfight between Hank Vaughn and Charley Long occurred in the saloon in 1881, and although both men were shot, both survived. Here the Singer Saloon is on the left, and the local stage depot is on the right. The saloon building was destroyed by fire in 1917.

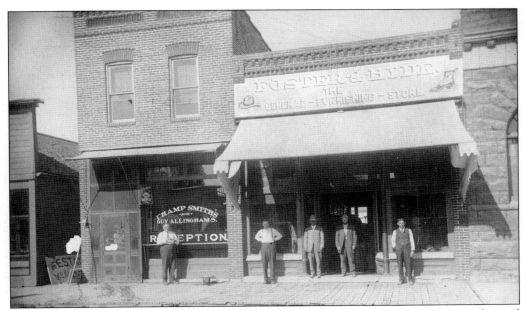

Saloons were quite popular in the growing frontier town. The Reception Saloon was located on the west side of Main Street between Third and Second Streets. Champ Smith acquired the property in 1900 and soon partnered with Isom Cleek. The saloon, known as "The Reception," was sometimes referred to as "Smith and Cleek." Smith later partnered with Guy Allingham. The building next to The Reception is the Foster and Hyde General Merchandise Store.

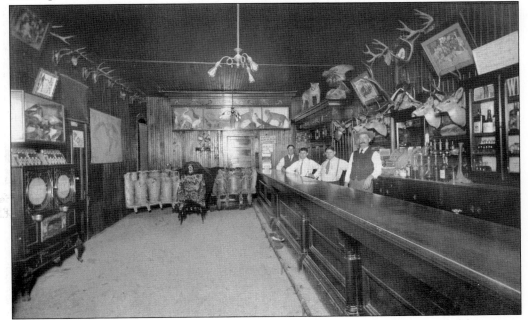

In 1886, Ed White purchased the Owens Saloon, located on Main Street. This view of the interior of Owens shows the early decor of a saloon, including the spittoons located along the base of the bar stand. Card games were quite popular, and the saloon offered billiards for customers. An early advertisement stated, "Come early, late and often."

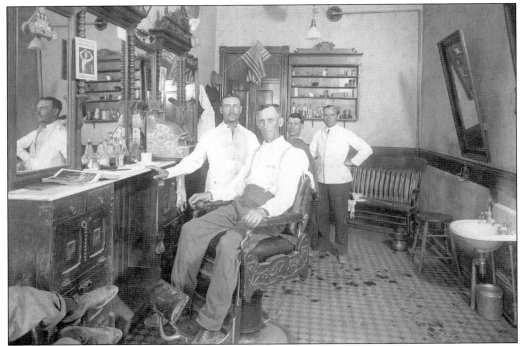

Lively conversations frequently occurred in barbershops. This interior view of an early barbershop shows local barbers Walt Hyde, left, and Bob Zevely. The shops were sometimes called "tonsorial parlors" or "shaving parlors." A shave and a haircut were advertised in early local newspapers for 25¢.

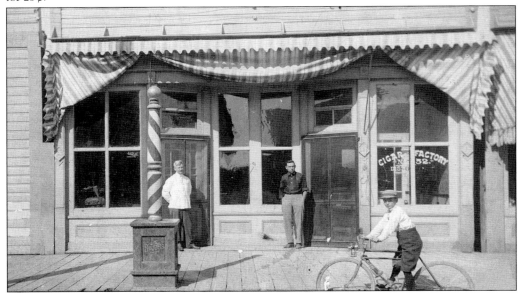

Barber Dick Darling stands outside the Hyde Barbershop, which was located on the west side of Main Street between Third and Fourth Streets. Keys Hyde is on the right near the Snoderly Cigar Factory. The young boy on the bicycle is Luckey Bonney. Cigar factories required permit numbers, and Cigar Factory No. 52 is painted on the window sign.

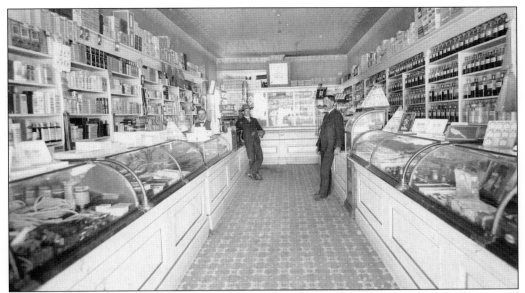

Drugstores were among the earliest businesses established in the community. David Templeton opened a drugstore in town in 1887, later partnering with his son John. The interior of the Templeton and Son Drug Store is pictured here in 1901. The store was located on the west side of Main Street between Third and Second Streets, and the Templetons operated in the same location from 1888 to 1913. Frank Spinning is behind the counter, John Templeton is to the right, and Dr. John Rosenberg is the gentleman with the hat.

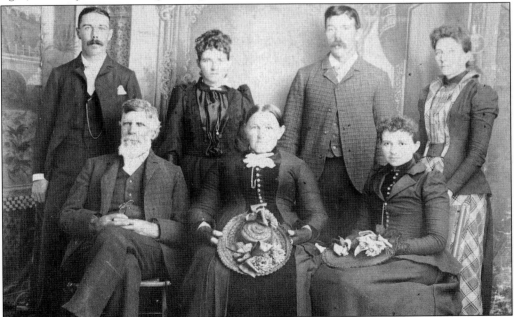

This photograph of the David Templeton family was taken at the end of the 19th century. Pictured from left to right are the following: (first row) David Templeton, Lavini Pell Templeton, Mattie Templeton Philiber; (second row) John Templeton, Ida Templeton Cantrell, Marion Templeton, Lizzie Templeton Vanderpool.

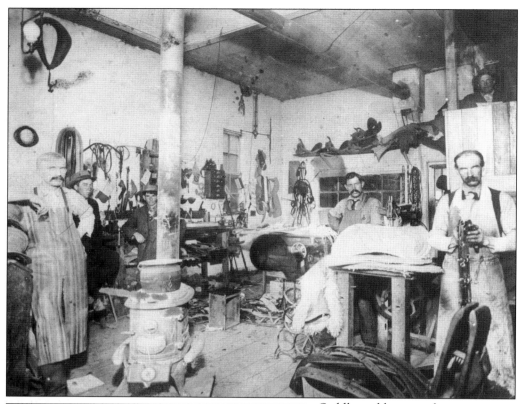

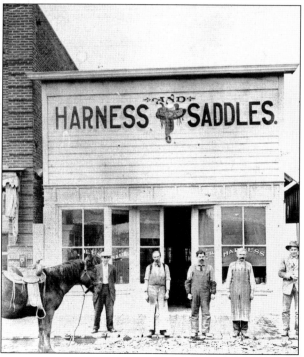

Saddle and harness shops were vital to early horse and mule transportation. This interior view of the H. D. Still Harness and Saddle shop reveals a cluttered appearance, which was the result of the busy nature of the work. The man in the front left is Charles Perrin, and the man in the back right is Dave Still. The smell of saddle soap and leather can almost be sensed from the photograph.

Dave Still purchased the saddle shop of J. W. Boone in 1910. This exterior view of the shop, located on the west side of Main Street between Fourth and Fifth Streets, shows owner Dave Still third from left and leather worker Charles Perrin fourth from left. The others in photograph are unidentified.

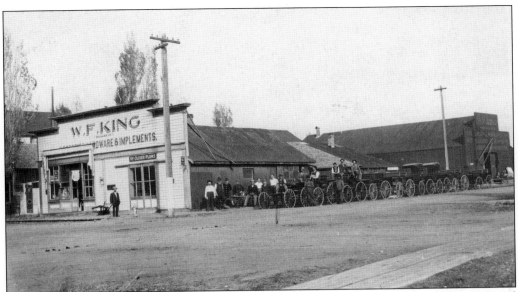

The W. F. King General Merchandise store specialized in hardware, farming implements, and horse-drawn wagons, buggies, and hacks. The store was located on the east side of Main Street at Second Street. Wagons and buggies are lined up on Second Street next to the store in this 1908 photograph. A blacksmith shop, located to the rear of the store, was a separate business operated by King.

William F. "Billy" King, an early entrepreneur in Prineville, came to the community at the beginning of the 20th century and soon partnered with his brother-in-law C. W. Elkins in a blacksmith and hardware business. In 1905, King bought out Elkins and operated the firm as W. F. King. When the business incorporated with partners in 1909, it was known as W. F. King and Company. King was active in local goings-on, was a lobbyist for local political interests, and became known as the "Silver Tongue" of Central Oregon.

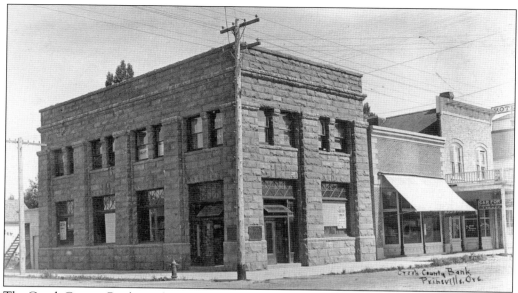

The Crook County Bank was first established in 1904 with capital provided by local businessmen. In 1910, a new stone building was constructed on the southeast corner of Third and Main Streets. The stone was quarried from a pit in the rimrock west of town. It continued to operate until 1920, when it met financial difficulties and was reorganized as the Bank of Prineville. In 1925, it became the Prineville National Bank and eventually closed during the Depression in 1931. The building now houses the A. R. Bowman Memorial Museum.

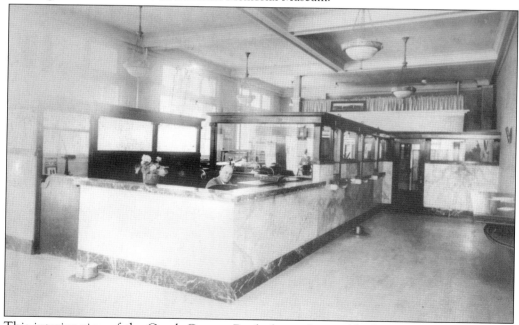

This interior view of the Crook County Bank shows the marble floor and counters, which presented a luxurious atmosphere for customers. The teller cages are in the center, and the bank vault is to the rear of the photograph. Most of the same interior is still in place at the site that is now the A.R. Bowman Memorial Museum.

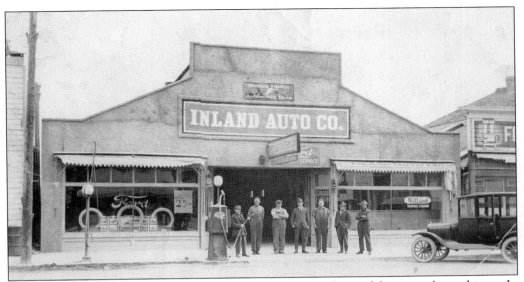

The arrival of automobiles into Central Oregon soon created a need for auto sales and parts. In 1915, one of the earliest stores to open in the community was Inland Auto Company, specializing in Ford sales and service. The business moved to the east side of north Main Street between Fourth and Fifth Streets. In this 1920s photograph, a group of employees stands in front of the store, which also featured a gas pump.

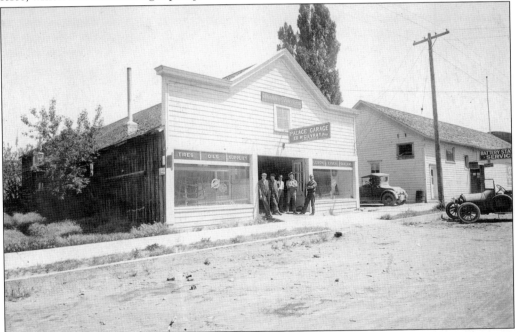

Repair shops and garages were critical to the continued operation of early automobiles. Blacksmith shops soon gave way to automobile garages. George McGilvray opened the Palace Garage on Third Street between Main and Beaver Streets in 1920. Employees stand in front of the business in this 1922 photograph. Millard Elkins opened a Studebaker dealership in the Palace Garage late in 1920 but later moved it farther east on the same block.

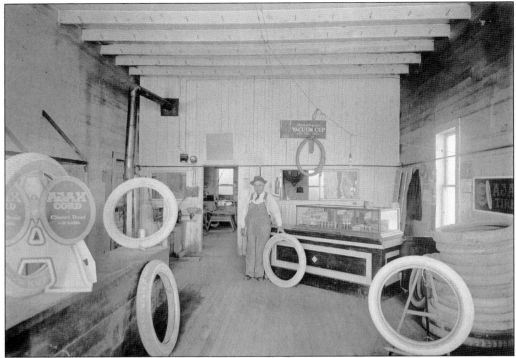

Tire shops were also a growing business need as the rugged roads of Central Oregon were rough on early tires. This photograph is believed to be the interior of Clark's Tire Shop, located on the southwest corner of Fifth and Main Streets. The business was originally the Prineville Vulcanizing Works, but the name was changed when L. K. Clark purchased it in 1919.

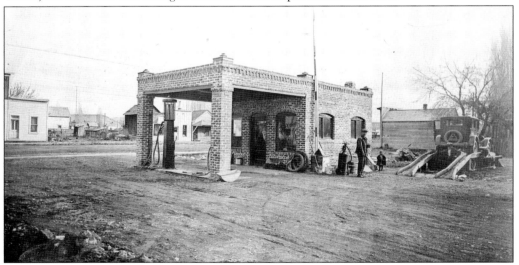

Gas and service stations began to emerge as necessary businesses as more and more automobiles came to Prineville. The Hubble Service Station, located at the southwest corner of Second and Main Streets, was established in 1925 and specialized in gas, tires, batteries, and oil. It was first operated by Lee Grimes. It was sold in 1928 to J. L. McDaniel and became known as Tip Top Service Station. Note the ramp to the right for oil service.

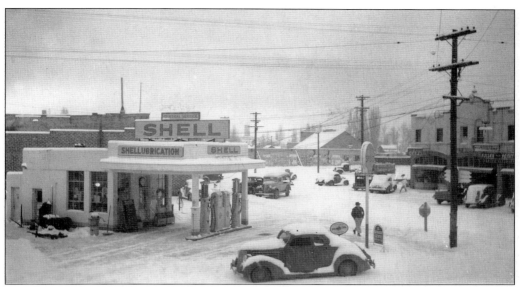

The Central Service Station, a Shell gasoline station established in 1929, was located on the northwest corner of Third and Main Streets and operated by Collins Elkins. The business, which featured a hydraulic hoist, repaired tires and even provided washing services for vehicles. This photograph, taken in the winter of 1937, shows the Ochoco Inn to the right.

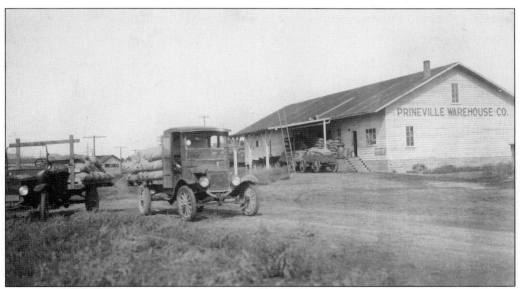

The Prineville Warehouse Company was established in 1921 and was constructed by the Tum-A-Lum Lumber Company. The warehouse, constructed along the City of Prineville Railroad line, was 100 feet by 40 feet in size. After its completion, a public dance was held in the building. The business was operated under a sublease by B. B. Groff. The site is now part of Ochoco Feed and Farm Supply.

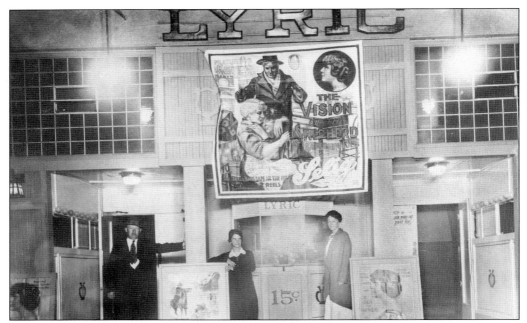

The first movie theater in the community was established in 1908 and operated in the Odd Fellows Hall building, but its commercial success was limited. In 1910, the theater moved to the old Glaze Hall on the west side of Main Street between Third and Second Streets, and its name was changed to the Lyric Theater. In 1911, it moved into a brick building just south of Glaze Hall. In 1923, it moved again—this time to the Ochoco Inn building—and operated there for many years. Van Brink, Dolly Hodges, and Ethel Douglas stand in front of the theater in 1912.

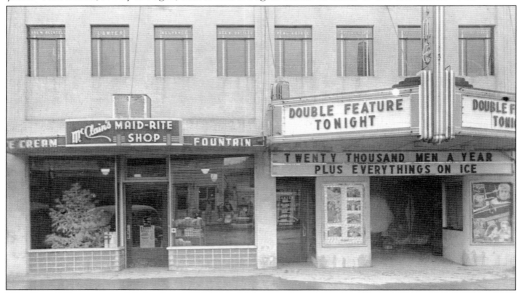

The Pine Theater, established in 1938 and operated by Ken Piercy, was located on the east side of Main Street between Second and Third Streets. The first movie shown in the theater was *Give Me a Sailor* starring Martha Rae. In 1971, the theater temporarily closed because of rowdiness and vandalism by youngsters. The building still stands with the movie marquee.

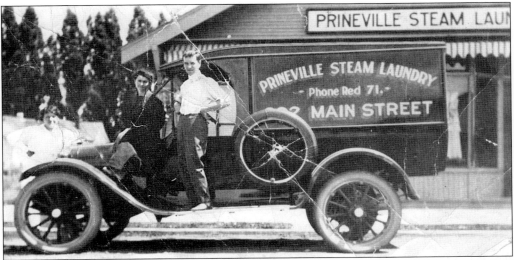

Steam-laundry service came to Prineville in 1923. The Prineville Steam Laundry was established on the corner of Sixth and Main Streets. It was first operated by John Becaas and had a series of owners. Mr. and Mrs. John Becaas stand on the service truck, and Mrs. Armons Hamilton stands to the left. John Becaas sold the business but maintained ownership of the property.

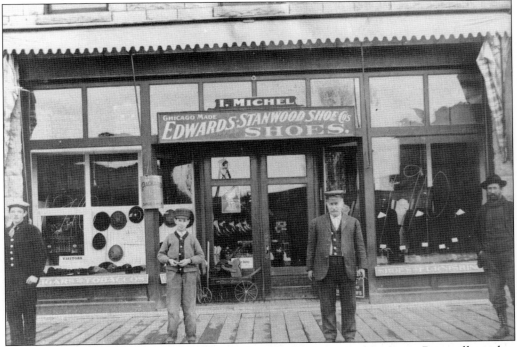

In 1901, Isadore Michel went into the merchandise business in downtown Prineville with a partner, and the firm was known as Michel and Risser's Bee Hive. Michel later took over as sole proprietor. He sold his business to D. E. Stewart in 1905 and established another store in the Hotel Prineville building. It became known as the I. Michel store and was located on the east side of Main Street between Third and Fourth Streets. Pictured from left to right are unidentified, Art Michel, Isadore Michel, and John Hunsaker.

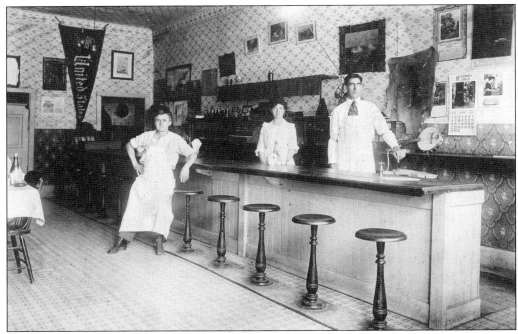

Small restaurants were popular after the beginning of the 20th century. The Little Gem Café, established in 1915, only operated for a short while. A calendar on the wall advertises the Hall and Davenport Market in Prineville. The clean and well-decorated establishment beckons customers to enter. The people in the photograph are unidentified.

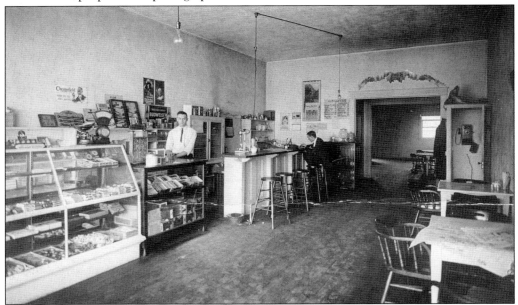

The Office Lunch restaurant, located in the Masonic hall on west Third Street between Main and Beaver Streets, was operated in 1924 by John Dobry. The café was a popular lunch and card room. Dobry sold the business in 1930, and it operated for several years under different management. The last owner of the business purchased the café in 1942 and eventually ceased operations.

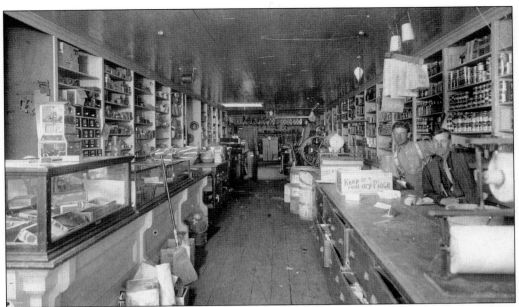

Omar Claypool bought the hardware and grocery stock of O. G. Adams and Company in 1914. The business was located at the northwest corner of Third and Main Streets. It later became the O. C. Claypool Company and moved to the northeast corner of Fourth and Main Streets. Claypool sold his business to Stewart and Lakin in 1918. Omar Claypool is pictured behind counter to the left. Next to him is Ralph Jordan.

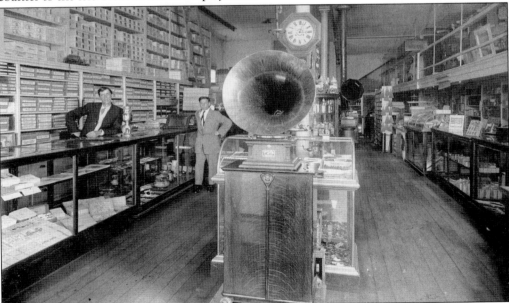

The Adamson and Winnek Company Drug Store began operation in 1898. The business dissolved in 1901, and Charles Winnek established the Winnek Drug Company in Belknap Hall on the southeast corner of Third and Main Streets. It moved in 1908 to the Claypool building on the northwest corner of Fourth and Main Streets. This photograph was taken inside the Winnek Drug Company store after it had moved to the Claypool building. The men are unidentified.

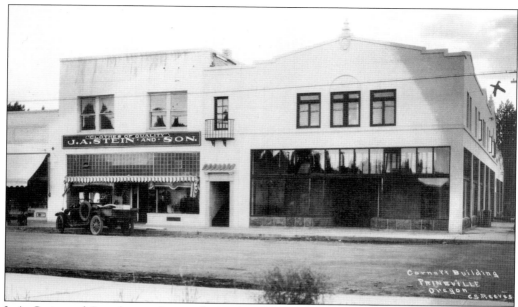

J. A. Stein and Son dry-goods store began business in 1925 and was located on the southwest corner of Main and Fourth Streets. The firm became a menswear-only store later that year. The building to the right was known as the Cornett Building and has been recently constructed when this 1925 photograph was taken. It later became the location of the Rollin Hatch dry-goods store. Both buildings are still in use today.

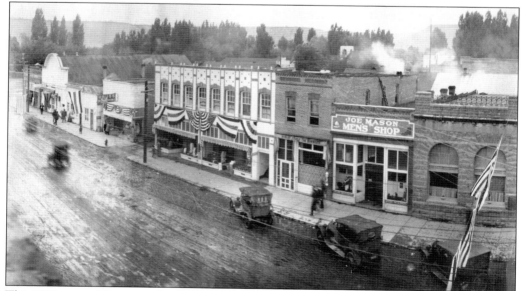

This 1923 view of the west side of Main Street between Second and Third Streets was taken from the roof of the present-day Bowman Memorial Museum. The First National Bank of Prineville is located to the right. Joe Mason Men's Shop, which operated from 1923 to 1927, is located just to the left. Zevely Barbershop, operated by Bob Zevely, is left of the Mason store. The Robinson and Clifton Clothing Store is to the left of the barbershop. Next to that is the Prineville Drug Company, operated by George Nicolai. All of the buildings are still in use.

# Three

# THE GROWTH
# OF A COMMUNITY

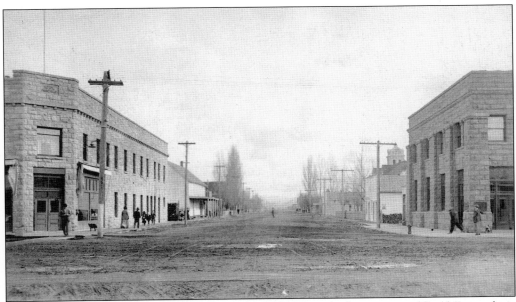

Prineville was becoming a bustling town in this 1912 view looking east on Third Street from Main Street. The stone Hotel Prineville is located on the left, and the new Crook County Bank is on the right. The wide streets are unsurfaced but provide spacious travel routes. Telephone and electrical poles line the street, and the clock tower of the newly constructed Crook County Courthouse is visible in the right background.

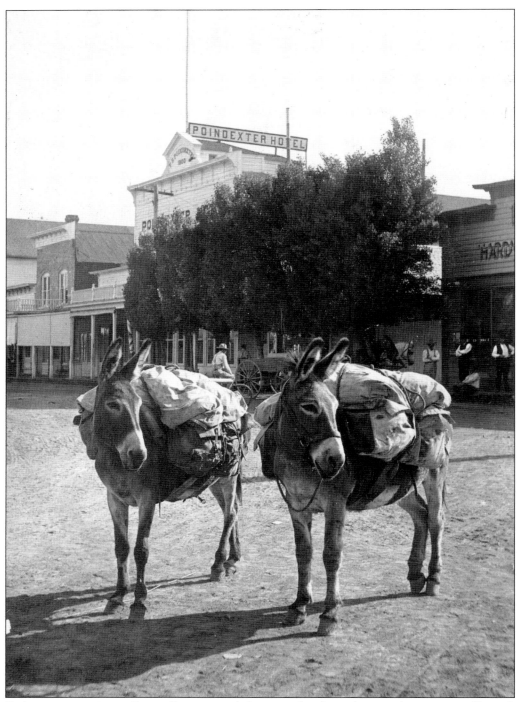

Early transportation to Prineville was mostly by stage, freight, or buggies, but occasionally pack mules ventured to town. This 1905 photograph of southeast Main Street shows two pack mules, with the Poindexter Hotel in the background. Trees are beginning to line the street, which in earlier years was mostly barren of vegetation. The Poindexter Hotel was built in 1900.

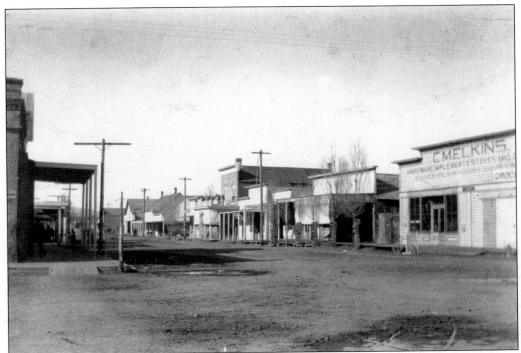

This 1905 view of Main Street looking north shows the east side of the street and the C. M. Elkins store on the right, the Singer Saloon, and the old wooden Hotel Prineville on the corner of Third and Main. Several changes would soon alter the look of the downtown area, including the construction of a new stone Hotel Prineville and a new stone structure for the First National Bank of Prineville.

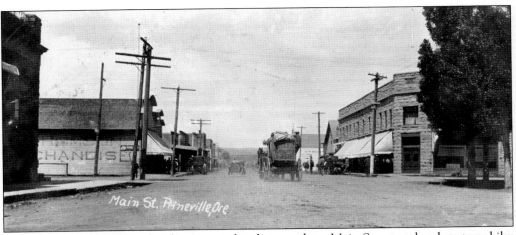

In this 1907 photograph, a freight wagon is heading north on Main Street and early automobiles are visible along the street. Hotel Prineville is to the right of the street, and the Wurzweiller and Thompson Merchandise Store is on the left. This image shows a mixture of old and new with the beginning of a transition to more modern transportation. The freight wagon is at the intersection of Third and Main Streets.

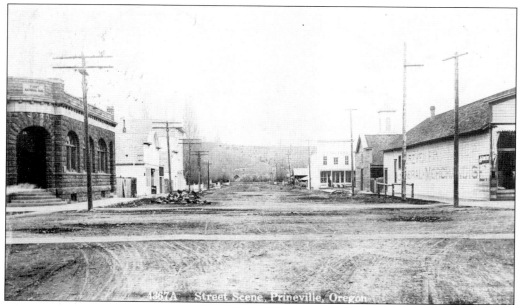

The First National Bank of Prineville was just completed at the time of this 1906 photograph, and rock debris from construction was still located on west Third Street. Main Street is in the foreground going from left to right. The Wurzweiler and Thompson Merchandise Store is on the right, and Lippman Furniture is in the background to the right. Second Street remained the primary road into Prineville from the west and east, as evidenced by the dead end on west Third Street.

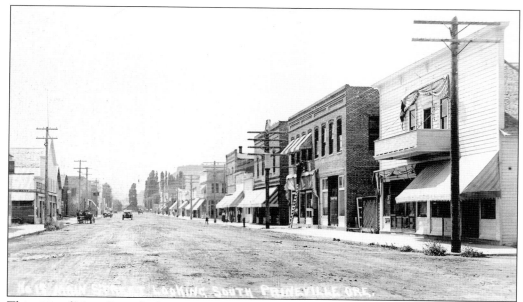

This view of Main Street looking south in 1911 reveals a growing number of brick buildings in the downtown area and a mixture of automobile and horse traffic. The photograph was taken from Fifth Street. Most of the west side buildings have canvas awnings to shade the wooden sidewalks and storefronts. The community is beginning to show signs of permanency.

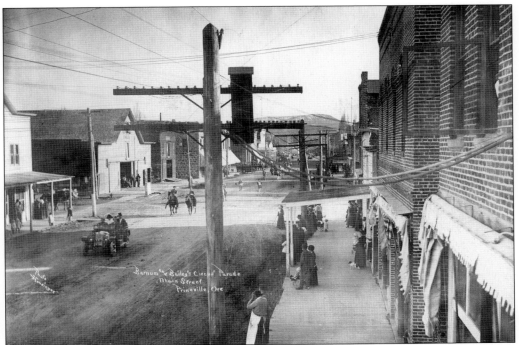

In 1911, a parade was held to showcase the arrival of the Barnum and Bailey Circus. Phone and electrical poles line the street and indicate a growing use of energy and communication opportunities. The number of buildings continued to grow on each side of the street.

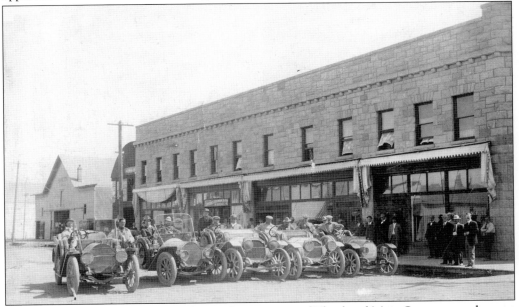

A group of automobiles line up at the northeast corner of Third and Main Streets near the west entrance of Hotel Prineville in this 1912 image. Early automobiles frequently attracted crowds to observe the "new fangled" machines, as they were still a novelty. Interestingly the automobiles all have steering wheels on the right side, and the drivers wear driving caps.

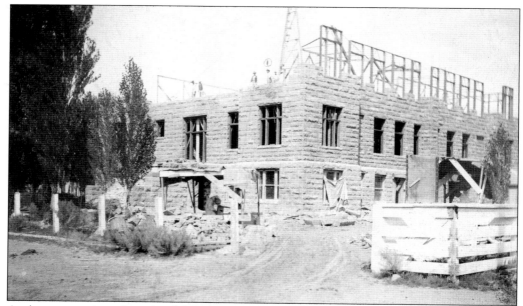

As the community enlarged and Crook County also began to grow in commerce and population, local residents determined that a new courthouse was needed. Construction began in 1908, and stone from a quarry in the rimrock west of town was used. Even as the building was being constructed, other communities in the county began to cry foul for Prineville daring to construct an expensive courthouse for which outlying areas would have to pay higher taxes.

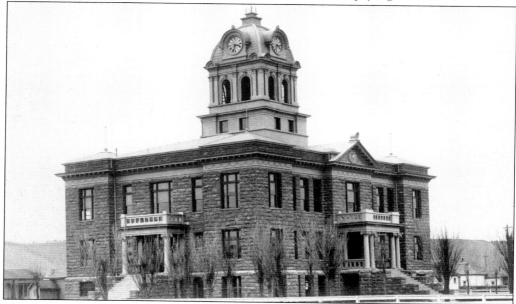

The new courthouse, completed in 1909, was one of the finest courthouses in Oregon. It had three stair entrances, on the north, east, and west sides of the building. A clock tower provided a time display to the cardinal points. It was constructed by local builder J. B. Shipp after the original contractors defaulted. Shortly after its completion, the northern and western portions of the county began to initiate actions to create new counties out of Crook County.

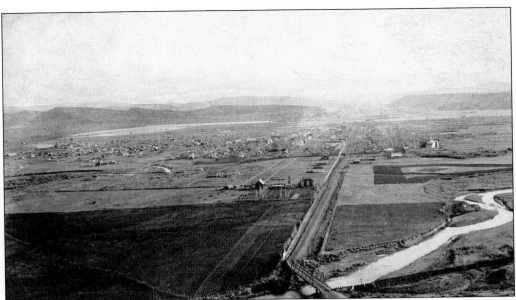

This panorama view of Prineville was taken in 1911; there is noticeable expansion out from the community's core. The new steel bridge is located below Viewpoint Rimrock, and the course of Crooked River has been diverted below the rimrock west of town. The old river course is still visible passing through town. The Poindexter Hospital is located in the mid foreground, and the new Crook County Courthouse is visible between Second and Third Streets.

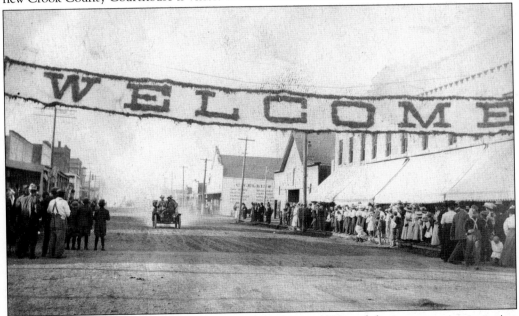

The Oregon Trunk Railroad arrived in Central Oregon in 1910, and there was great expectation that new prosperity would occur. Unfortunately for Prineville, the railroad bypassed the community. Prineville attempted to woo Louis Hill, son of railroad magnate James J. Hill, into building a sideline to the community. A welcome reception, complete with banners, and a major parade was held for Louis Hill. Unfortunately the railroad connection was never built by the Hill interests.

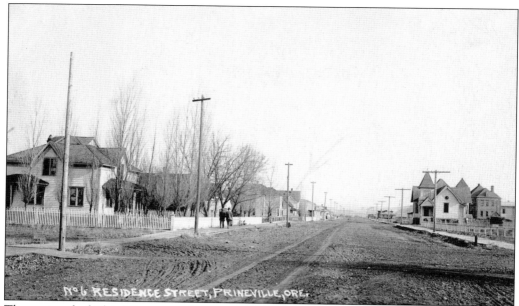

No 6 RESIDENCE STREET, PRINEVILLE, ORE.

The east end of Third Street was beginning to develop by the time this 1910 photograph was taken. The Presbyterian church can be seen on the right, and the new Crook County High School building is visible behind the church. Houses can be seen to the left, and boardwalks were expanding east with new construction. Third Street remained only a secondary route in town.

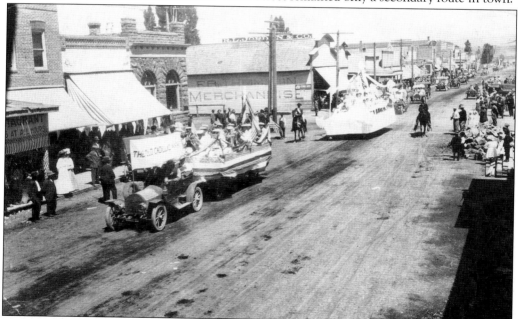

A Fourth of July parade in 1910 reveals a vibrant community. It had a lot to celebrate in 1910. Business was expanding, the railroad had arrived in Central Oregon, and a new courthouse had been constructed. This view looks north on Main Street, and Third Street is in the midsection of the photograph. Construction stone for the new Crook County Bank is visible in the street to the right.

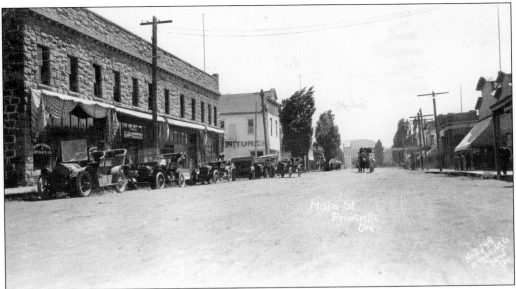

Automobiles line the street in this view looking south on Main Street in 1910. Although wagons still appear, they will soon be gone from the scene. Hotel Prineville is to the left, and the old wooden Belknap Hall houses a furniture store at the southeast corner of Third and Main Streets.

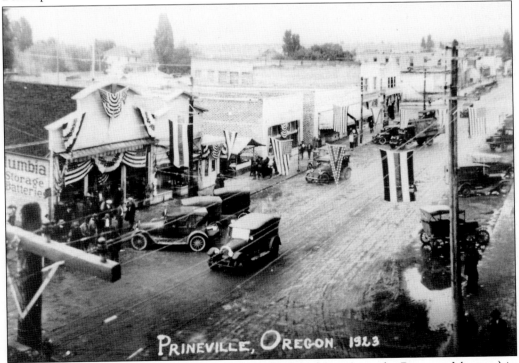

This view is from the roof of the Crook County Bank building (now the Bowman Museum) in 1923. Automobiles now dominate the streets, although they remain unpaved, and the beginnings of traffic problems are visible. A Fourth of July celebration is nearing as banners and flags are proudly displayed on the buildings and across the streets.

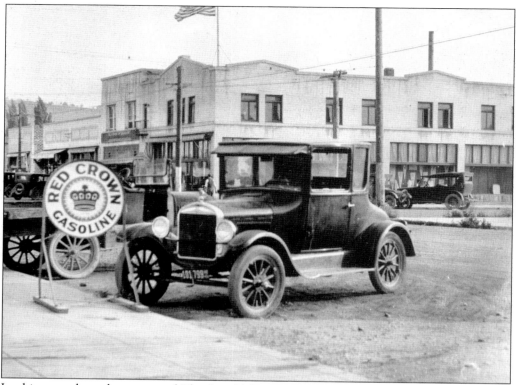

Looking north at the corner of Third and Main Streets in 1924, the new Ochoco Inn can be seen in the background. Numerous automobiles are parked at an angle along the streets, which remain unpaved. Gasoline sales are more common as the number of vehicles increases in the community.

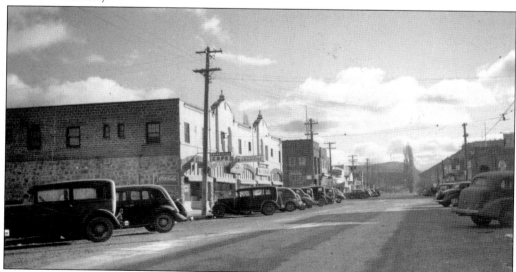

This c. 1938 view looks south on Main Street. The Prineville Café, Ochoco Hardware Store, and a Safeway market are located on the east side of the street in the Ochoco Inn building. Numerous cars are parked along the street, revealing an active business section.

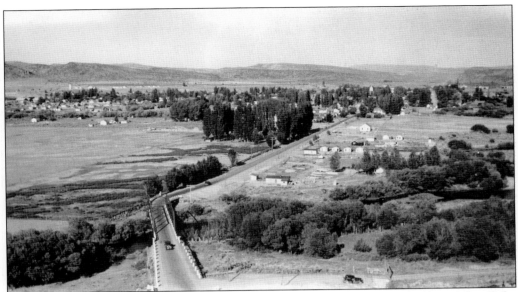

This 1935 view from the rimrock west of town reveals that a concrete bridge has replaced the old steel bridge across Crooked River. Second Street remains as the main route to town from the west. The flat area west of town is beginning to have some structures built but is still sparsely occupied. Lumber mills are just beginning to be established in town.

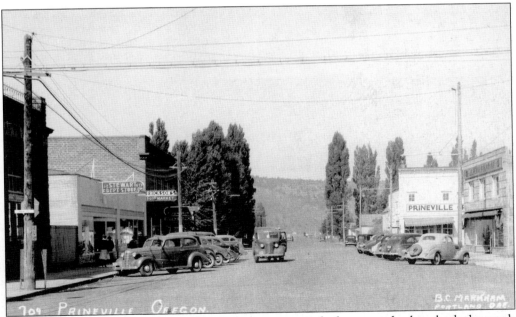

In this 1938 scene, west Third Street has numerous cars parked at an angle along both the north and south sides. Trees are growing along the street, which is wide to provide for ample parking and vehicle traffic. To the left is the Stewart Department Store and Erickson's Market, and on the right is a J. C. Penney store. The old Lippman building houses the Prineville Furniture Store in the background.

61

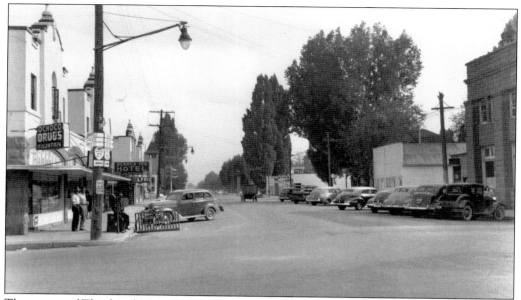

The corner of Third and Main Streets, looking east on Third Street, appears to be nostalgically inactive in this 1939 view. Ochoco Drugs is located in the Ochoco Inn building, and the hotel sign is just beyond the drugstore. The old Crook County Bank building is to the right but, at that time, was an insurance and title company owned by Arthur Bowman. There are numerous trees along the street, and the roads are now partially surfaced.

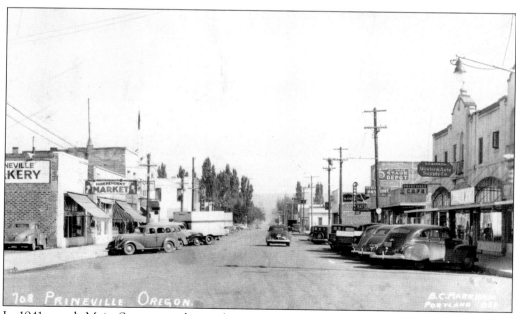

In 1941, north Main Street reveals new businesses on both sides of the street. The Prineville Bakery and Independent Market are located on the west side of the street, and the Western Auto Hardware store, Prineville Café, Pastime Saloon, and bus depot are located on the east side. Concrete sidewalks have replaced wooden boardwalks.

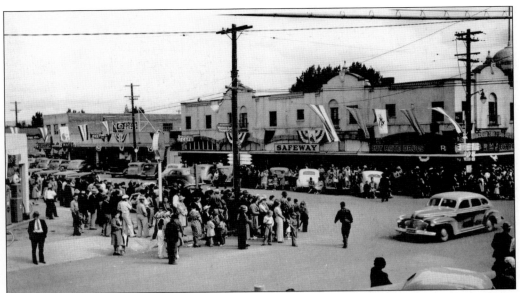

The town celebrates with a rodeo parade along Main Street in 1943. This view looks northeast from Third Street toward the Ochoco Inn building, where Cut Rate Drugs is located in the southwest corner. The Safeway store is still present but, in 1944, it closed its doors when the manager John Wangler was inducted into the service. It never reopened.

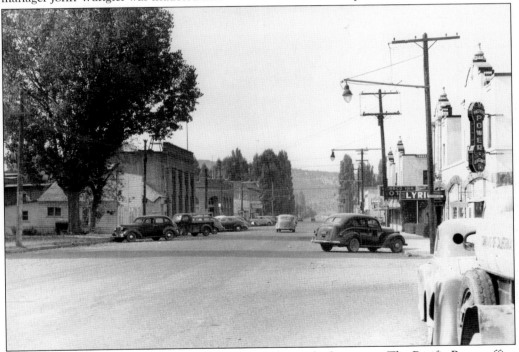

Third Street remains a little-used street in this 1942 view looking west. The Pacific Power office and the Lyric Theater are located in the Ochoco Inn building. The A. R. Bowman office is in the former Crook County Bank stone building to the left, and Prineville National Bank is across Main Street to the west.

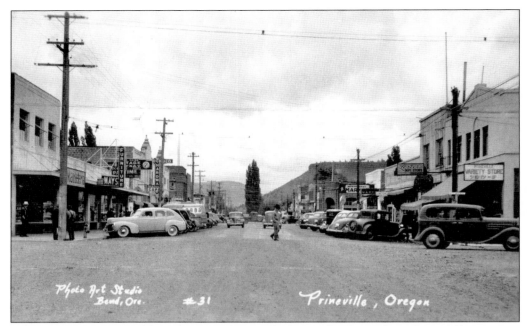

A busy Main Street is visible in this c. 1945 view. The Prineville Variety Store, Lester's Department Store, Michel grocery, and Independent Market are located on the west side of the street. The Marketeria Meat Market, Mays Furniture, Pastime Saloon, Mount Hood Stage Depot, Prineville Café, and Ochoco Hardware are on the east side of the street.

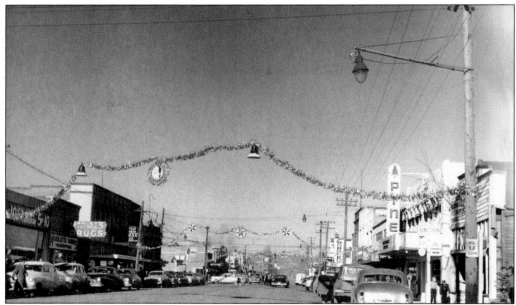

Main Street had numerous businesses in this 1952 view looking north. The Pine Theater is on the east side of the street, and LeMert's 5 and 10 Emporium, Manley's Drug Store, Prineville Men's Wear, and Ochoco Café are on the west side. The town was actively growing in the postwar years, with nearly full employment in local sawmills. It was the beginning of a very prosperous time for the community.

# *Four*

# COMMUNITY SOCIAL DEVELOPMENT AND ACTIVITIES

The Alpha Literary Society women's basketball team at Crook County High School in 1912 included, from left to right, Allie Horigan, Blanche Wilson, Nora Livingston, Louise Summers, and Nora Stearns. Early high school sporting activities were limited, particularly for girls. Competition was among the literary groups at Crook County High School because other local communities had not established regular high schools. The somewhat cumbersome uniforms and shoes must have provided extra entertainment for spectators.

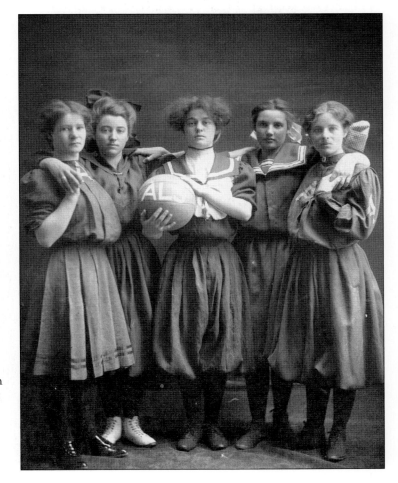

The Crooked River Bridge on Second Street provides an opportunity for residents to take a leisurely pause after church services in 1890. Pictured from left to right are Minnie Crooks, unidentified, and Emma Ketchum. The bridge was a popular gathering place.

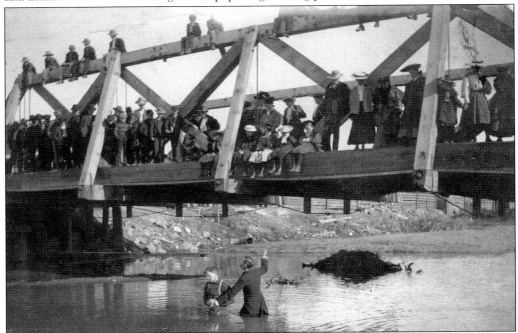

Baptisms were popular community events, and a large crowd has gathered on the Crooked River Bridge to witness this one in 1900. The Crooked River was often a muddy stream, and conducting baptisms in its waters was an experience worth watching.

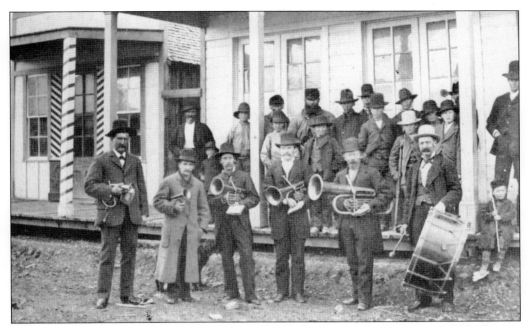

The first community band in Prineville was established by local saloon owner Til Glaze in 1880. The band was quite popular and provided some of the first entertainment for the frontier community. The members of the band from left to right are Til Glaze, Lucien Gilbert, Starr Maley, Jim Hamilton, Mr. Vollrath, and John Hunsaker (with the drum).

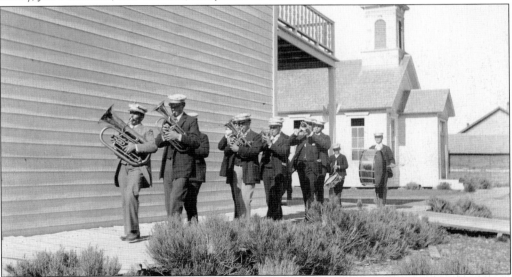

The second town band was established by Warren Glaze. It consisted of mostly brass instruments with drummers. In this 1898 image, the band is playing for a special event at city hall, which was located on the upper floor of the building to the left. The Union Church is in the background. Band members, from left to right and from front to back, are Jack Shipp, Adrian Crooks (front right), unidentified (partially obscured), Prince Glaze (middle right), unidentified (obscured), Otto Gray, unidentified (obscured), Frank Chamberlain, Warren Glaze, Ridgely Draper (on small drum), and Allie Vollrath (on large drum).

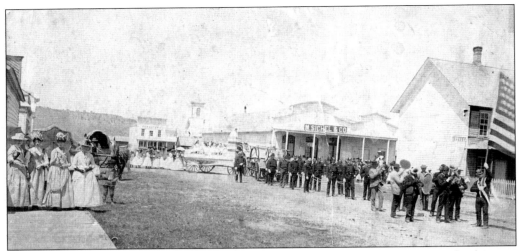

Holiday celebrations were popular events for the community. In this 1888 view of Third Street, the Prineville Volunteer Fire Department pulls a hand-operated pump wagon and follows the town band. Ladies stand on the boardwalk dressed in their best attire. The Prineville Hotel can be seen to the right of the photograph, and the Sichel store is located at the northwest corner of Main Street.

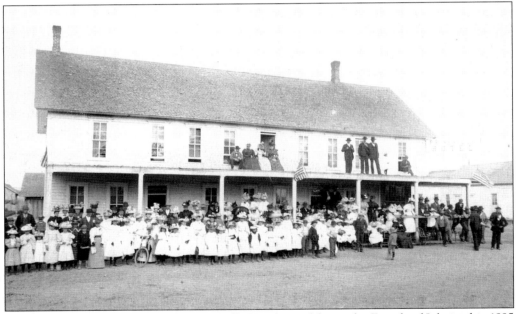

A large crowd has gathered at the Prineville Hotel to celebrate the Fourth of July in this 1895 photograph. The day usually began with a parade, followed by feasting, merriment, and a day of socializing with everyone dressed in their finest clothing. In an era when there were few opportunities for entertainment, local residents took full advantage of public holidays to celebrate with neighbors.

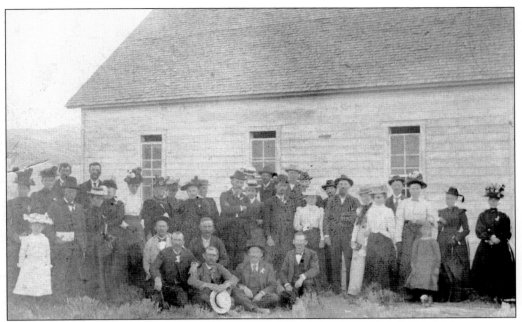

Most early religious activities in the developing community were centered on "revivalist" movements or circuit-riding priests. Eventually churches were established, with the first being the Union Church in 1881. It was located on the north side of Third Street between Main and Beaver Streets. In this faded photograph, the congregation is gathering in front of the Union Church in preparation for a sermon by Deacon Lawson.

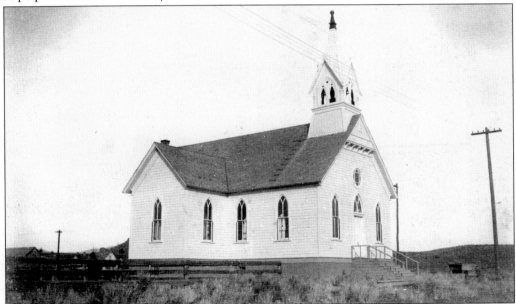

The arrival of churches to the frontier community began a period of social binding. The Methodist church, the second church established in Prineville, was located at east Fourth and Court Streets, and had its first sermon in 1889. Numerous other churches would emerge as the rough-and-tumble town became more civilized.

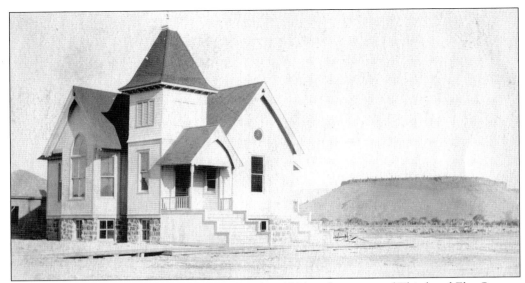

The First Presbyterian Church was constructed in 1904 at the corner of Third and Elm Streets, at the site now occupied by Washington Mutual Bank. In this view, the building has just been completed, and Foster Mesa is visible in the background to the southeast. There were few structures near the church when it was first built. The church was razed in the 1950s, when the congregation merged with others to form the Community Church.

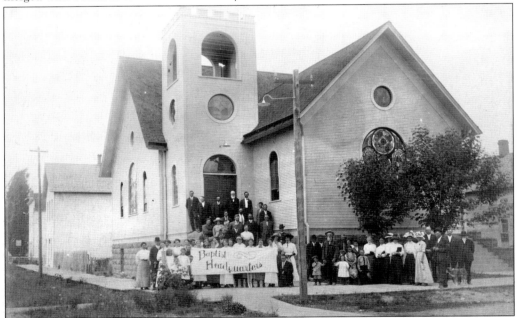

Organized as early as 1873, the first Baptist church held its services in the old Union Church for several years. The first building constructed for the congregation was built in 1912 and was located on west Second and Beaver Streets. During the Depression, the church operated on a sporadic basis because the congregation could not afford a regular clergyman. The building was the last of the original five main churches to remain standing and was demolished in 1966 when a new building was constructed.

70

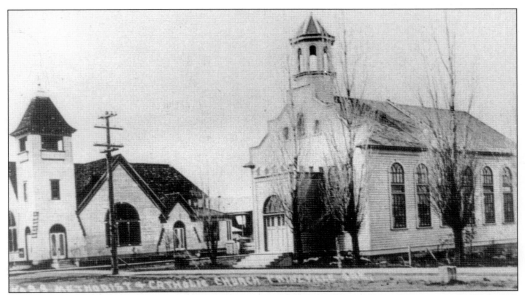

Traveling Catholic priests provided early services to Prineville, and it was not until 1915 that the first Catholic church was constructed. Built at Third and Court Streets, it was known as St. Joseph's Catholic Church. After its completion, there were five main church steeples visible in Prineville. The original church remained until the current brick structure was built in 1949 at east First and Main Streets. The new Methodist church is located in the left background.

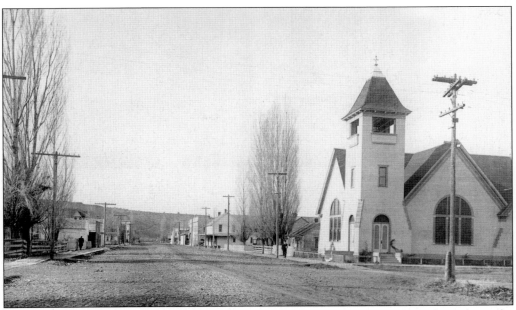

This view, looking west on Third Street, shows the new Methodist church to the right at the corner of Court Street and the stone Hotel Prineville in the background. This structure was built when the original church was destroyed by fire in 1906. After World War I, several churches were established in the community, and Prineville became known as "the town with a gas station and church on every corner."

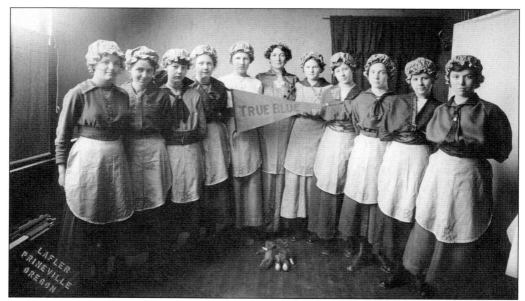

Churches often formed youth groups to promote family life. This group of young women is the "True Blue" Sunday school class at the Baptist church, which encouraged domestic pursuits. From left to right the girls are unidentified, Ruth Yancey, Beryl Davis, Edith Smith, unidentified, Mrs. Ayers, Tillie Zell, Dora Gould, Bessie Pancake, Amanda Harris, and Helen Ayers.

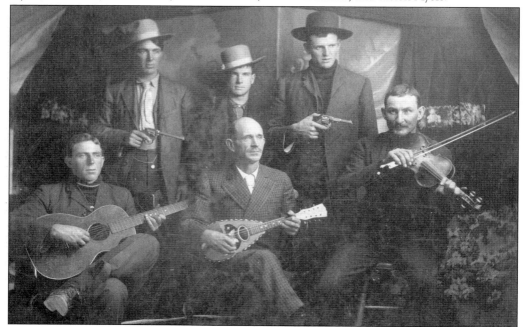

It was common for humorous photographs to be staged in the early 20th century. In this image, a group of Prineville musicians is backed by "gun-toting" men, making for an interesting mixture of weapons and musical instruments. Pictured from left to right are the following: (first row) Bill Stroud, unidentified, Joe Treichel (with fiddle); (second row) Charles Stroud, unidentified, Cecil Young.

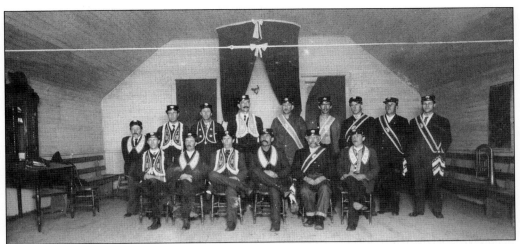

Social organizations were quite popular in most towns in Central Oregon. The Independent Order of Odd Fellows was initiated in Prineville in 1873 and designated as Ochoco Lodge No. 46. The original location for the Odd Fellows Hall was First and Main Streets, but the building burned, and they then met in a building that had been moved to west Second Street and Claypool. Many prominent local pioneers were charter members of the organization, and they held meetings in the hall until 1972, when the building was sold. The organization continued to operate in Prineville until it was consolidated with the IOOF in Madras. Officers of the Ochoco Lodge are pictured here about 1900.

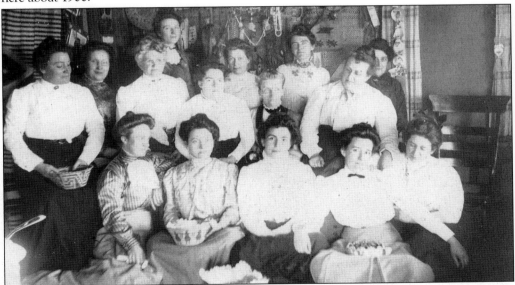

Social organizations for women were quite common near the beginning of the 20th century. Some, such as the Rebekah Lodge and the Order of the Eastern Star, were formed in conjunction with men's organizations. One of the early women's literary-based organizations was the Shumia Club. Organized in 1908 by Ada Millican, the name is a Paiute word that is believed to mean "to think, to study." Members of the charter organization are, from left to right, as follows: (first row) Minnie Clifton, Emma Gray, Lulu Rosenberg, Pearl Kyler, Ethel Edwards; (second row) Anna Winnek, Margaret Elkins, Ada Millican, Lizzie Lafollette, Catherine Conway, Rova Brink, Marjorie Brink, Rose Parrot, May Wigle, Mattie Elliott. The club is still active today.

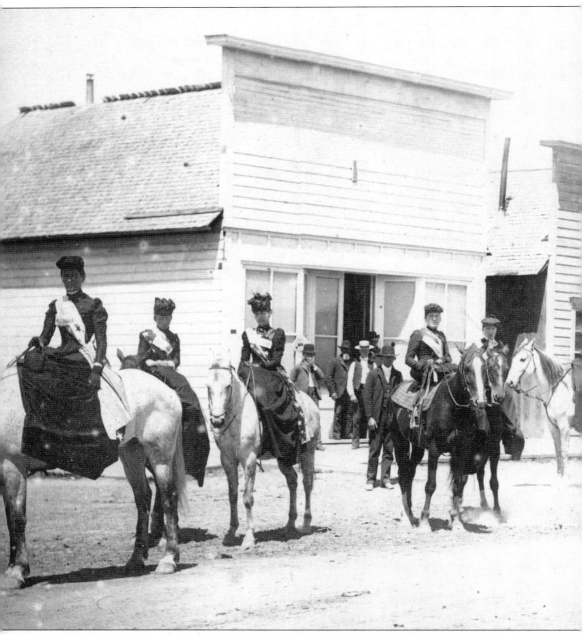

At the intersection of north Main Street and Fourth Street in this *c.* 1884 photograph, an unidentified group of women, possibly an equestrian group, are riding horses sidesaddle in a parade. Sidesaddles made riding for women difficult and cumbersome, but it was not considered "ladylike" to ride straddled as men did. Some women became very adept at riding horses on a sidesaddle, and these women were evidently good riders. The women are wearing banners across

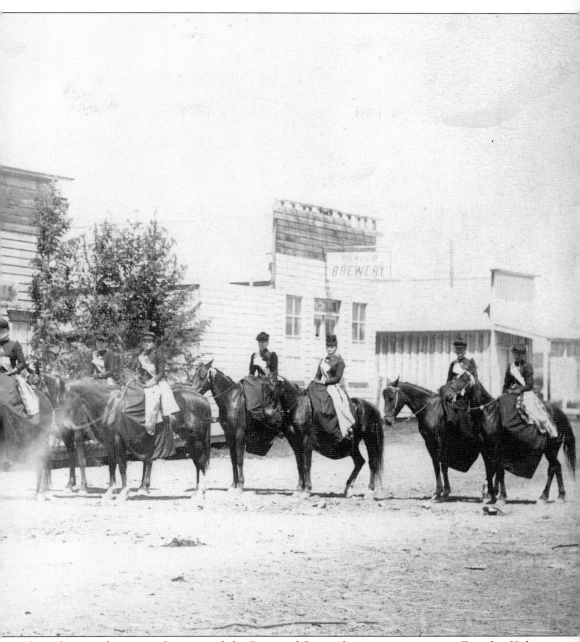

their chests with names of states, and the Stars and Stripes banners suggest it is a Fourth of July parade. Early photographs of parades in town seldom show such a large group of women riders. In the background are a photography shop and the Ochoco Brewery, which advertised in the local newspaper that "it is now making better beer than ever before and that we keep the best of beer on tap in our cellar." The building was destroyed by fire in 1888.

A community gathering on the Fourth of July in 1895 draws a large crowd. The man with the white beard on the wagon is B. F. Nichols, the "Father of Crook County." Women and children particularly enjoyed the social events because they could take advantage of the opportunity to have lively conversations with other women, and the children could frolic with one another. Celebrations often lasted all day and into the evening.

A ground-breaking ceremony takes place south of the brick Crook County High School in this 1911 photograph. The location suggests that the ceremony is for the start of construction on the new brick Prineville Grade School. The smokestack of the Prineville Power Plant can be seen at right, just north of the high school.

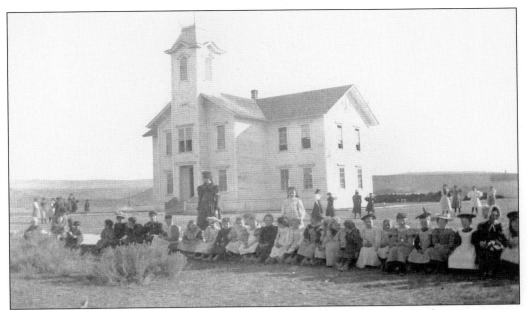

The first public school in Prineville was constructed in 1887. The two-story wooden structure was located at the site of the present Pioneer Park, west of Elm Street and between Second and Third Streets. There is a large area of open space in the background to the southeast. Local residents were extremely proud of their school, and there was a high priority for education of youngsters. The school was used from 1887 to 1910.

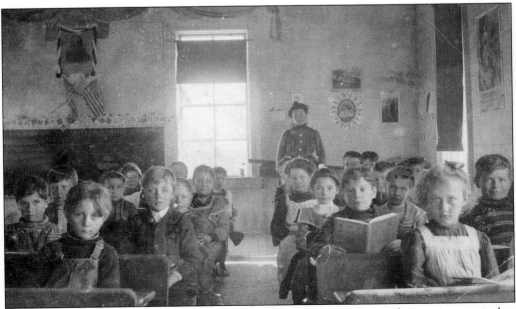

A classroom inside the old Prineville Public School building in 1901 reveals a spacious room, but curiously the students are crowded close together in the desks. The teacher is at the back of the room, and a photograph of recently assassinated Pres. William McKinley is on the back wall.

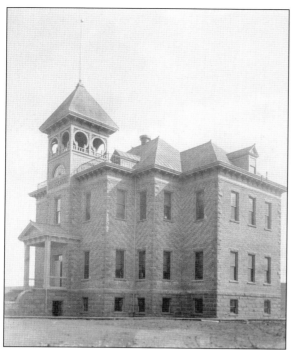

Prineville became one of only a handful of communities that could boast of a high school when this three-story brick building was constructed in 1904. It was a prominent community landmark and was the only high school in Central Oregon. Students attending from outlying communities, such as Bend, Redmond, and Madras, had to board with families in Prineville to attend the school, which was located on Third Street and east of Fairview Street. The Crooked River Elementary School is now located at the site.

This group of students returning home from attending school in 1896 are, from left to right, Jessie Ketchum, Lizzie Ketchum, Dan LaFollette, Emma Ketchum, and Randolph Ketchum. The older students attended Prineville Academy, as there was no high school until 1904. The buggy is just west of the wooden Crooked River Bridge.

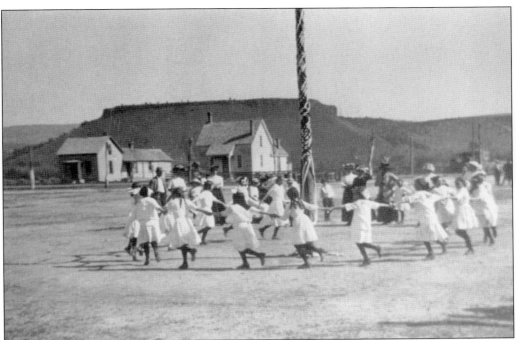

The public schools proudly presented programs and performances to parents and community members, including this May Day dance by a group of young girls dressed in white. These events were fun for children and gave them a chance to show what they had learned in school besides reading, writing, and arithmetic.

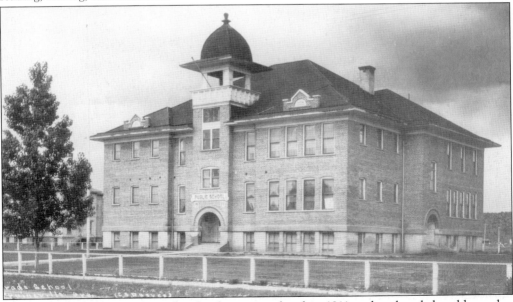

This new three-story brick grade school was completed in 1911 and replaced the old wooden Prineville Public School building. Combined with the high school located just north of the grade school, it created an imposing set of buildings in the community. They were among the tallest buildings in the community, only surpassed by the courthouse.

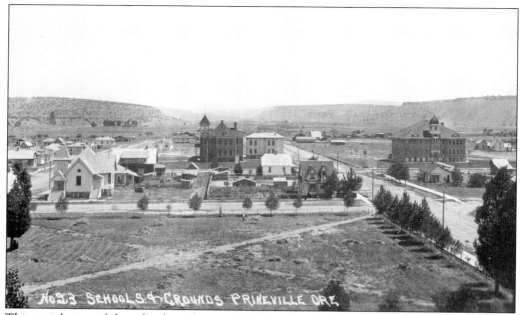

This aerial view of the schools and grounds is from the clock tower of the courthouse looking east. The impressive school buildings are separated by Second Street, which remained the main passage through town. The old wooden courthouse had been moved to the school grounds and placed near the high school as an annex. The Presbyterian church is located to the left on Third Street. A field located between the courthouse and Elm Street is the current site of the police department and Pioneer Park.

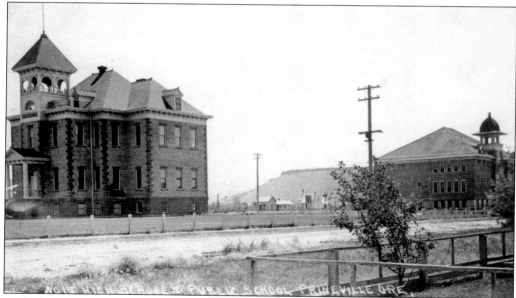

Both the high school and the public grade school can be seen in this view, looking southeast from Fairview Street in 1911. Visitors frequently commented on how visually impressive the schools appeared. Unfortunately neither building was strongly constructed, and by the 1930s, both buildings had been demolished and new structures built.

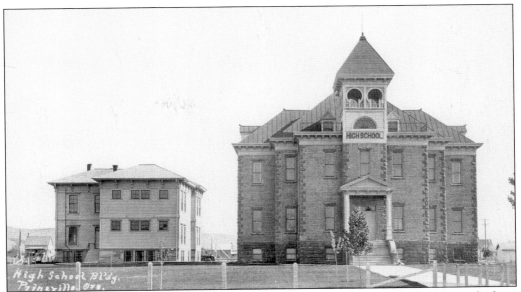

This view of the high school and the old courthouse annex was taken from Third Street looking south. The main entrance of the school faced Third Street. A variety of subjects were taught at the school, including manual shop for boys and domestic housekeeping for girls. Although rarely used, Latin was taught because it was thought to be necessary for a well-educated graduate.

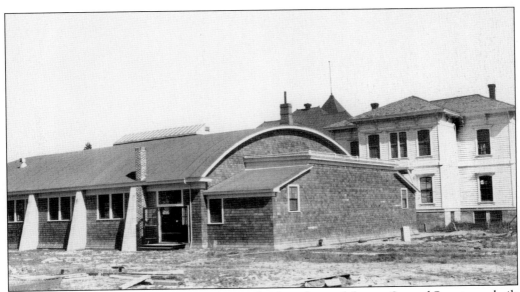

A new school gymnasium, located on what used to be a thoroughfare on Second Street, was built in 1928. It blocked traffic from continuing east, and Third Street became the main thoroughfare. Crooked River Elementary School still uses the gymnasium. Here the old courthouse annex is behind the gym and the top of the high school is visible.

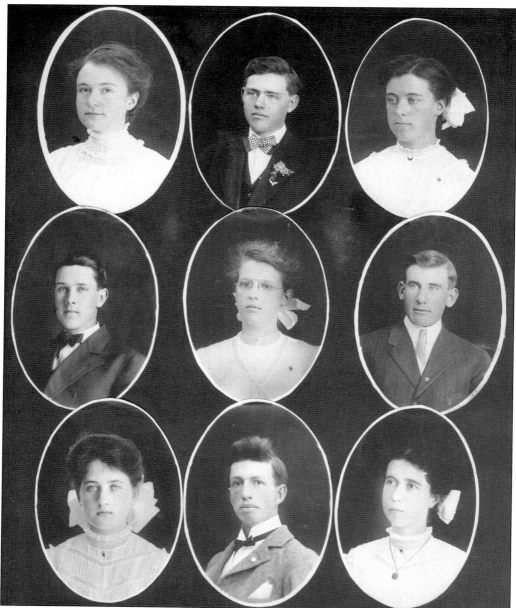

The first class to complete all four years of instruction at Crook County High School graduated in 1908. Members of the graduating class were, from left to right, as follows: (top row) Beulah Crooks, Arthur Linborg, Elsie Osborn; (middle row) Orrin Mills, Celia Nelms, Reuben Booton Jr.; (bottom row) Clara Horney, Luther Moore, Edna Estes. It was a proud moment in the education system of the community.

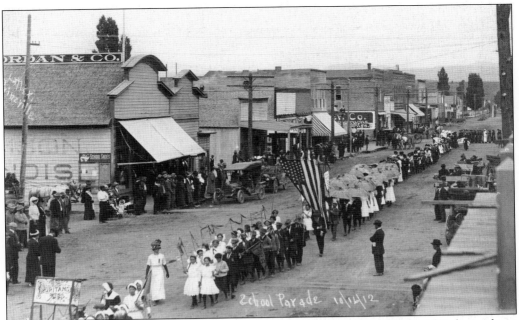

Prineville schools celebrated Columbus Day with their own parade in 1912, and it drew a large crowd of local residents. Looking north on Main Street at the intersection of Third Street, a teacher and other onlookers display the latest in ladies' hat fashions.

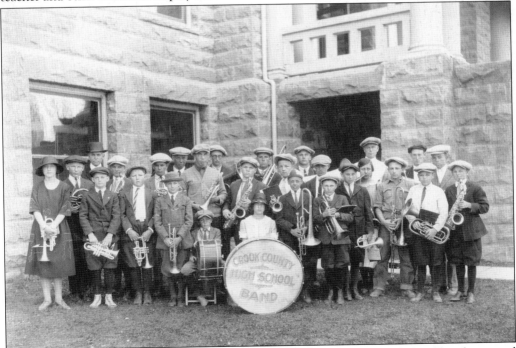

Since it was first established in 1904, Crook County High School has had a school band, pictured here in 1926 at the Crook County Courthouse. The band played at various social events and usually paraded around the courthouse grounds performing popular marches of the day.

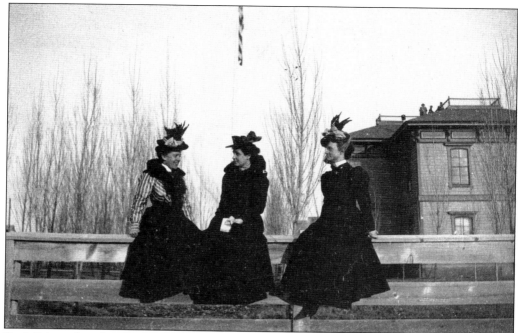

Socializing after church services on Sunday was a favorite activity. Three young ladies sit on a fence in front of the First Crook County Courthouse enjoying a leisurely conversation in this 1900 photograph. Note the group of men on the roof of the courthouse viewing the city.

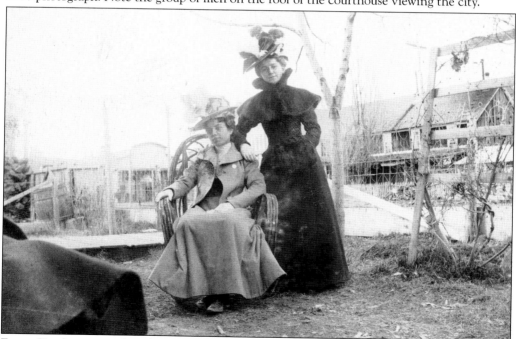

Emma Ketchum, seated, and Effie Crooks are enjoying the company of other friends after church in 1900. The back of the Poindexter Hotel is in the right background, and the back of Frank Elkin's blacksmith shop is to the left.

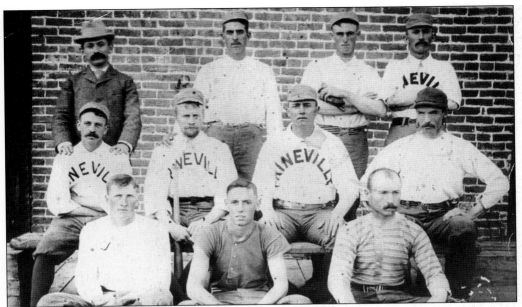

Community sporting events were very popular at the beginning of the 20th century, and the rising popularity of the game of baseball came to Prineville with the establishment of its first town team in 1890. Players on the first team are, from left to right, the following: (first row) Linn Walton, Walter Luckey, Emmet Holman; (second row) Frank Poindexter, Frank Sommerville, Mark Carey, Tom Baldwin; (third row) Manuel Sichel (manager), Joe Elliott, John Darsey, Ves Belknap.

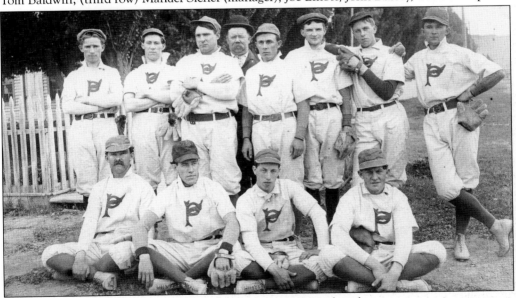

After the beginning of the 20th century, intercity sports rivalries began to grow as more towns established baseball teams. The teams had huge neighborhood support and were often a symbol of community pride on the developing frontier. This is the 1906 Prineville town baseball team. Pictured from left to right are the following: (first row) M. Smith, Dr. Rosenberg, Ralph Jordan, Ray Constable; (second row) Grover Jamison, Gail Newsom, Pat Roark, Leaner Liggett (manager), Bruce Gray, Don Steffs, Frank Foster, Mart Bailey.

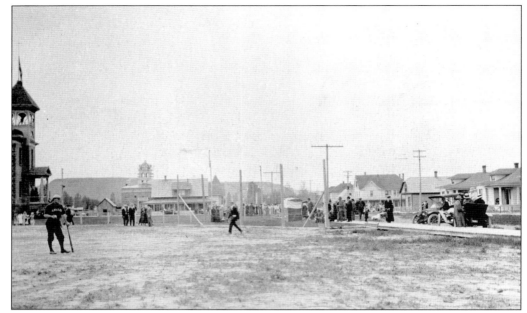

When Prineville played a visiting team from a neighboring community, many businesses closed and most of the community would show up to watch the game. Here the Redmond team is playing Prineville at the school grounds in this 1910 photograph. The high school is to the left and the courthouse is in the background.

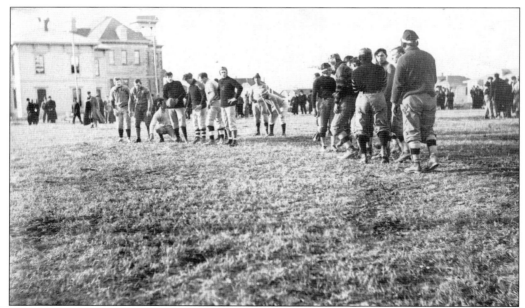

In 1911, football was a relatively new sport in Central Oregon. Some local men gathered together to form a team to play Bend that year. The first football game was played in Bend and ended in a disappointing tie. Another game was proposed, and the Prineville team heavily recruited star college players living in Redmond to play for them. The second game against Bend was played in Prineville on the school grounds, and the home team won 17-0.

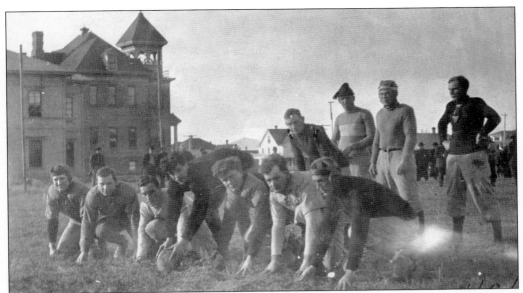

The first Prineville town football team lines up for a team photograph on the Prineville school grounds before the second game was played in Central Oregon. The linemen, from left to right, are the following: (first row) Ernest Coe, Bubb Barnes, Tom Quinn, Curley Thompson, Roy McCallister, two unidentified men; (second row) Lake Bechtell, Sam Ellis, Bob Gumm, Ray Brewster.

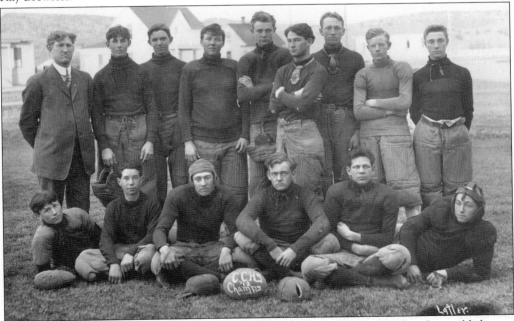

The development of high schools in other communities of Central Oregon led to the establishment of high school athletic teams, which soon began to replace local town teams. Football was one of the earliest established high school sports. Crook County High School dominated local sports in the early years of the 20th century. This photograph depicts the 1912 Central Oregon Champs from CCHS. Each player furnished his own equipment and his own transportation to games.

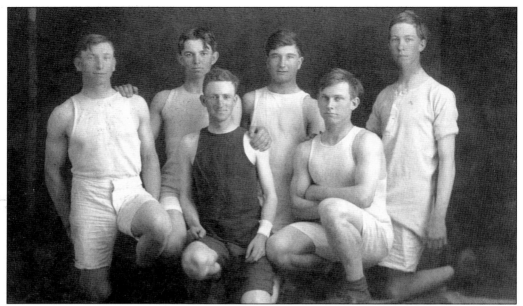

Basketball was first played with intramural squads at Crook County High School from 1904 to 1909 because there were no other schools to compete against. After other high school were established, a school team was developed in 1910. The members of the first CCHS basketball team are, from left to right, as follows: (first row) Warren Yancey, Roland McCallister; (second row) Clarence Rice, Roy McCallister, Robert Lister, Ray Lowther.

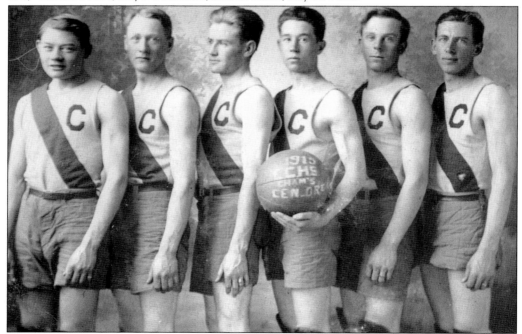

This 1915 basketball team was the champion of Central Oregon. The scrappy team, although short on height, was quick and nimble. Members of the team are, from left to right, Frank Brocius, Harold Charleston, Harry Stearns, Bub Estes, Roy McCallister, and unidentified.

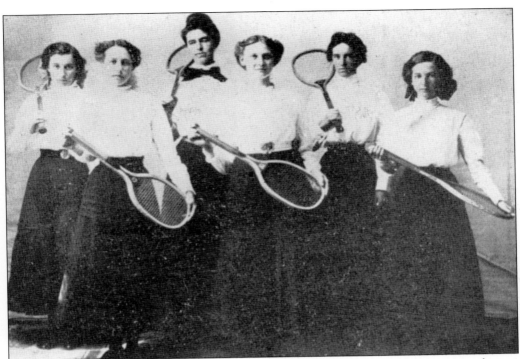

Women's high school sports were limited in the early years; basketball and tennis were the two main sports for women. The local school had two tennis courts, and tennis tournaments were held at the school. Tennis attire for women appears to be somewhat bulky in this 1910 photograph of the women's tennis team.

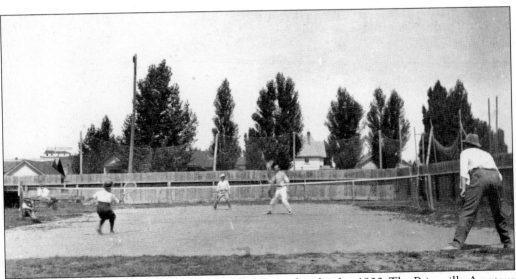

Tennis became a very popular sport in the community shortly after 1900. The Prineville Amateur Athletic Club established a dirt tennis court behind the club building, and competitors of all ages played in matches. Matches were all outdoors, and the dirt courts often became muddy with the slightest moisture. It was often difficult to maintain court boundary lines.

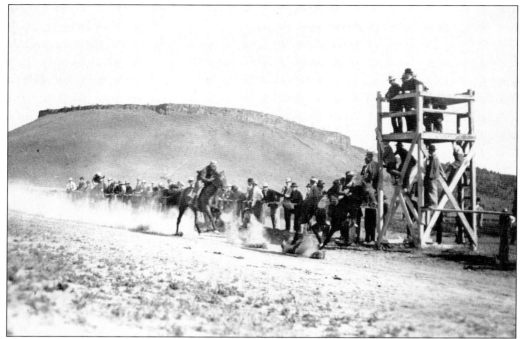

Horse racing was among the most popular sports activities in the local area, and this 1905 image shows a horse race in Prineville. Prineville had a racetrack at the east edge of town, and horses from throughout Central Oregon came to race. Betting on popular horses made for exciting times. Foster Mesa is in the background.

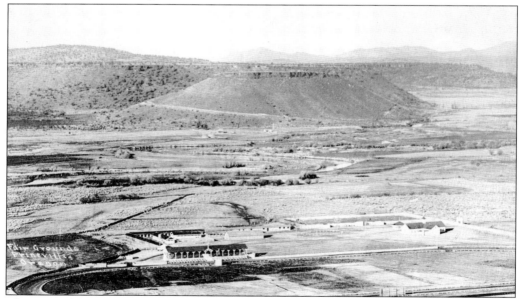

This view of the Crook County Fairgrounds and oval racetrack, included in the fairgrounds when it was first established in 1910, was taken from Foster Mesa, looking west across Crooked River Valley to the Viewpoint Rimrock. A grandstand is located near the finish line of the horse track. Races often drew large crowds from all over the region.

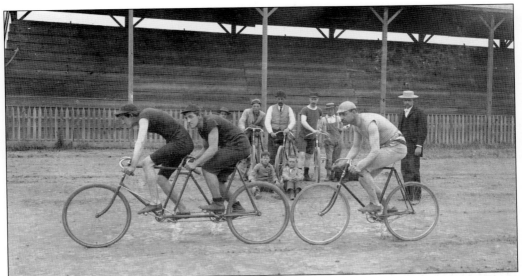

Bicycle racing became a popular sport at the beginning of the 20th century. Although bicycles were slow to gain popularity in horse country, the competitive spirit soon found its way to bicycling. Here local bicycle enthusiasts are warming up for a race at the Crook County Fairgrounds in 1910.

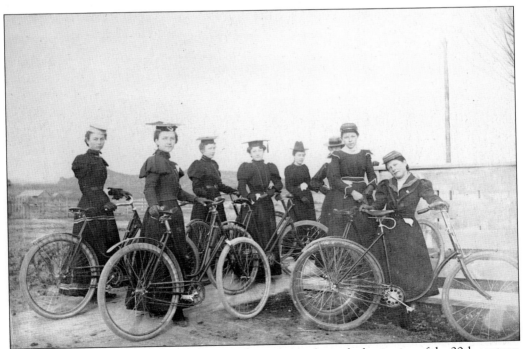

Recreational bicycle riding in the community became popular at the beginning of the 20th century. In this 1903 photograph, a group of young ladies from the Prineville Academy are on a "Bicycle Party" outing and stopped to have their picture taken on the Crooked River Bridge. Prineville Academy was a teachers' school before the establishment of Crook County High School.

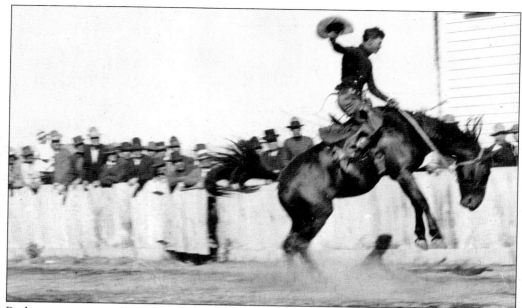

Rodeos were among the earliest sports events in the region, and cowboys often showed off their skills in competition. Prineville had its first rodeo about 1900. Early rodeos were held on a regular basis at the Crook County Fairgrounds, and the popularity of the events led to the establishment of the Crooked River Roundup in 1945. A local "bronc buster" is riding a bucking horse in this 1919 photograph at Crook County Fairgrounds.

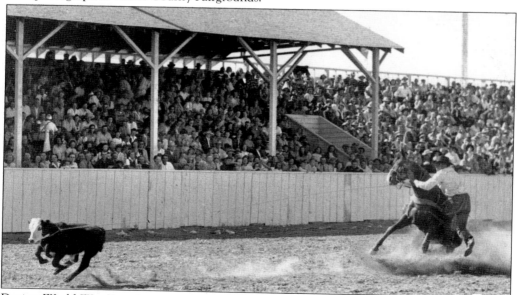

During World War II, rodeos were not held in Prineville. However, after the war, several local rodeo enthusiasts formed a board to establish the Crooked River Roundup as a stop on the professional rodeo circuit. The first rodeo was held in early September 1945, and mostly local amateur cowboys competed. It was a big success, and the next year it was part of the professional rodeo circuit. The rodeo became a main community event and has been held annually since its beginning in 1945.

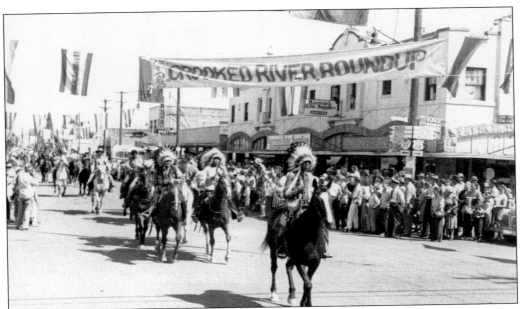

To promote the Crooked River Roundup, an annual parade was held to welcome rodeo competitors and those coming to watch the rodeo. The rodeo parade was one of the main events in the community, and tribal members from the Warm Springs Indian Reservation frequently participated in the parade and rodeo. This photograph shows some of them leading the parade in 1958.

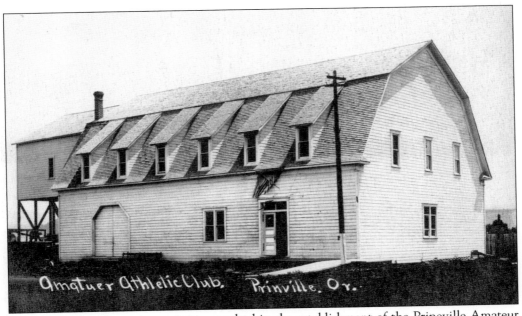

The enjoyment of sporting activities resulted in the establishment of the Prineville Amateur Athletic Club around 1911. Located in the old Commercial Club building (forerunner of the chamber of commerce) at the corner of First and Main Streets (where the Catholic Church now stands), the club provided a variety of athletic opportunities for local residents.

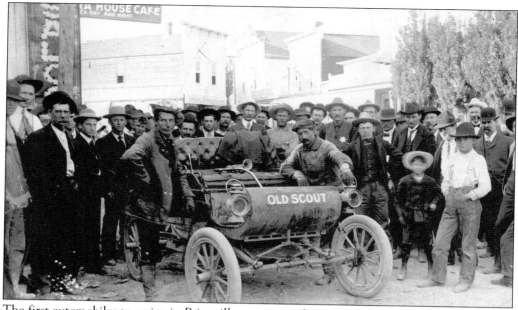

The first automobiles to arrive in Prineville were part of a transcontinental race, from the East Coast to the Lewis and Clark Exposition in Portland, between two early Oldsmobile vehicles in 1905. "Old Scout," the first car to arrive, was driven by Dwight Huss and a fellow traveler. The entire community gathered around to view the "horseless" carriage. Many did not think the machine had much of a future.

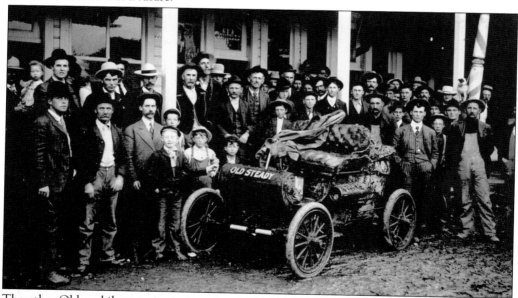

The other Oldsmobile to arrive in town was "Old Steady." Unfortunately the vehicle caught fire during refueling in Prineville and part of the back was damaged. It is seen here in front of the Poindexter Hotel with proud local residents posing by the machine. After leaving Prineville, the two vehicles crossed over the Santiam toll road. The gatekeeper did not know what toll to charge the contraptions, as he had never seen one before. He decided that since they took up the whole road, he would charge the rate for a hog.

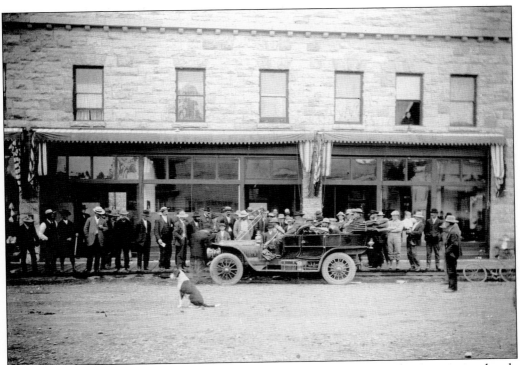

Automobiles began to gain favor as a popular mode of transportation in the community shortly after the arrival of those first cars. This 1911 Cadillac, which brought Louis Hill to Prineville for community meetings on railroad construction, sits in front of Hotel Prineville around 1912, while several spectators gather to admire it. Although automobiles were becoming more common, they still fascinated early residents.

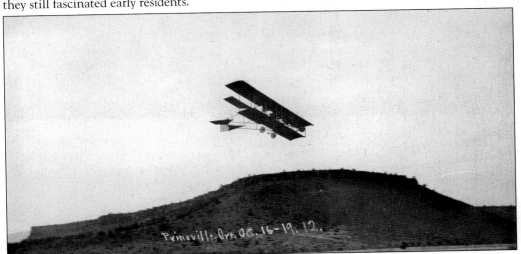

The first airplane arrived in Prineville in October 1912. The plane was a spectacular new invention that drew a large crowd to watch the pilot perform daring feats of flying. As the pilot was performing maneuvers close to the ground, his wing came in contact with the head of local resident Stowell Cram, who was 83. The crowd rushed to his aid and a local doctor administered to him, but Cram died from the trauma. It was the first fatal accident involving aircraft in Central Oregon.

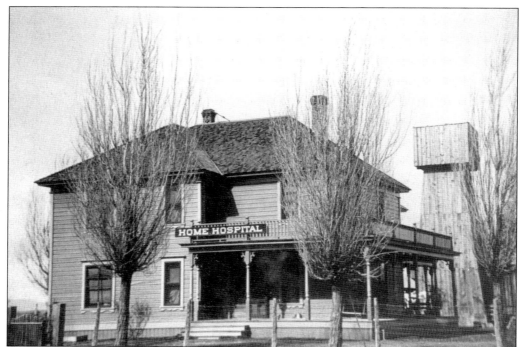

Beginning in 1912, the first hospital in Prineville was Home Hospital, located on the western edge of town at the corner of Locust and west Second Street. It originally operated as a limited hospital and later as a nursing home. Cost for hospital care was $1 per day. Other buildings served as a hospital through the years, including the former home of "stagecoach king" George Cornett.

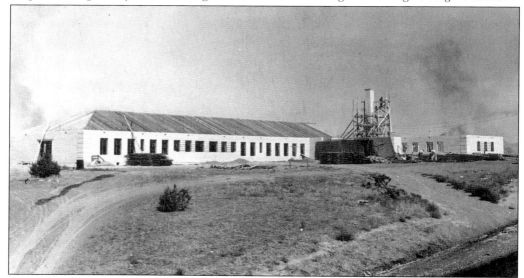

As the community began to grow after World War II, it was decided a modern and more adequate hospital facility was needed. A local group formed a board to raise the funding necessary to build the new hospital in 1950. Most of the money was donated by local contributors. Here Pioneer Memorial Hospital is under construction. The original building still stands but has modern additions.

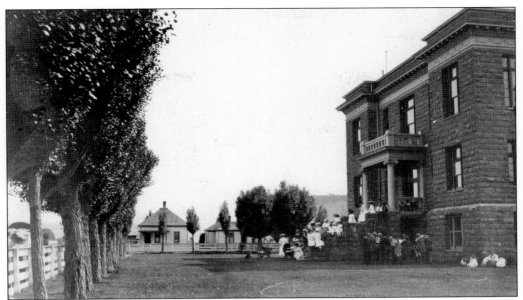

The completion of the Crook County Courthouse in 1909 was a major milestone in the community, and it became a popular gathering place for social events. Shortly after its completion, a group of local women and students met on the east staircase to celebrate. A band is playing near the steps. This view looks south.

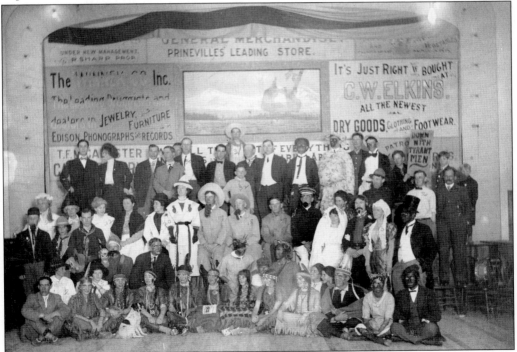

A local theater group formed to present three-act plays in the old opera house, located on the west side of Main Street between Second and Third Streets. The cast for the play *High Jenks* poses for this 1912 photograph. Many prominent local residents were in the cast.

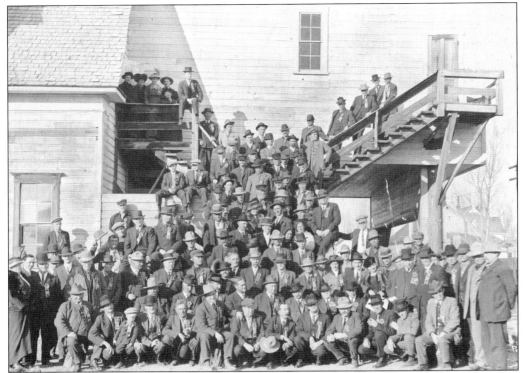

Prineville was a prominent community in the early livestock industry of Oregon, and this group attends the first meeting of the Oregon Stockmen's Association (later named the Oregon Cattlemen's Association) held in Prineville in 1915.

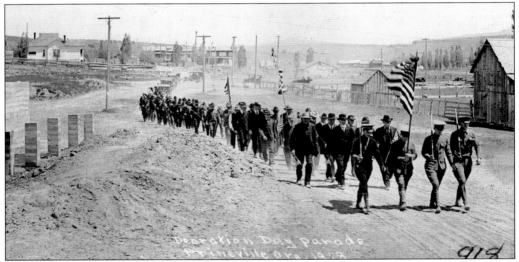

Residents were highly patriotic and actively celebrated national holidays honoring the country and its heroes. After World War I, Decoration Day was declared a national holiday and local citizens had a memorial parade that traveled north from town to the cemetery where local heroes killed in action were honored. The procession on north Main Street is beginning to climb the hill toward the cemetery in this 1918 photograph.

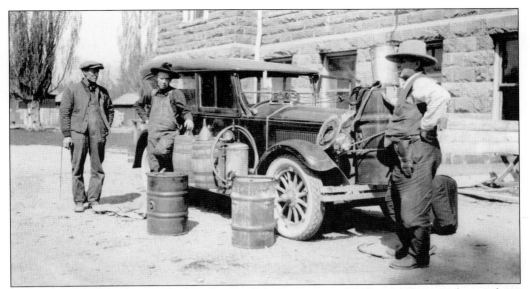

The Prohibition era led to legal action being taken against many local entrepreneurs who sought to supplement their income with the sale of illegal alcohol. Sheriff Steve Yancey had just confiscated a still from an outlying area around Prineville at the time of this 1921 photograph, taken behind the courthouse. He proudly displays his contraband.

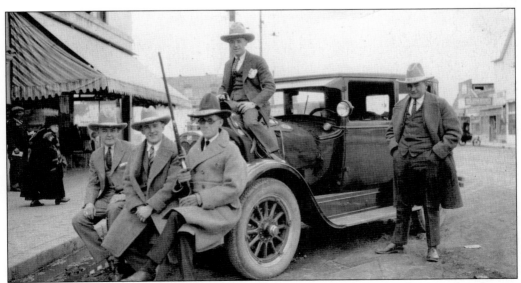

Local law enforcement officers take time to clown around in this 1921 photograph, taken in downtown Prineville. Sheriff Steve Yancey, right, and his deputies are armed and ready for action, including the one straddling the car.

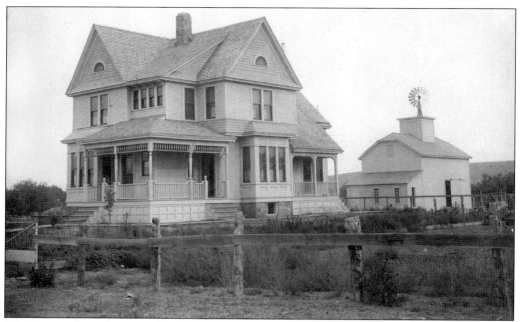

Wealthy residents began to build luxurious homes in Prineville at the beginning of the 20th century. C. M. Elkins, a local businessman, contracted with John B. Shipp to construct a house. The total cost for construction was $2,500 when completed in 1897. It was the first home to have indoor plumbing in Prineville, and the house still is in use as an apartment building.

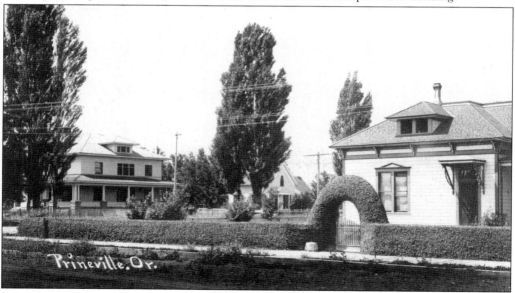

Tom Baldwin, a local banker, built the house on the left on First Street near the intersection of Main Street. The Syd Stearns family later acquired the house. The house in the middle was built by Henry Hahn, a local businessman, and was located west of the Baldwin house. The house on the right was the home of county judge Marian Brink and was on the west side of Main Street near the intersection with First Street. The site of his home is now the location of the BPOE Elks Lodge.

# Five

# WORKING ON

# THE RAILROAD

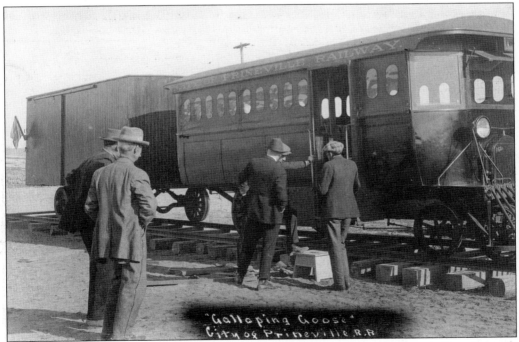

"Galloping Goose"
City of Prineville R.R.

The City of Prineville constructed a city-owned railroad line from Prineville to a junction with the Oregon Trunk Railroad near Redmond in 1918. The community feared it would become a ghost town without a link to the only major railroad passing through Central Oregon. One of the earliest engines, affectionately called the "Galloping Goose" by local residents, was gasoline powered and carried only limited freight and passengers.

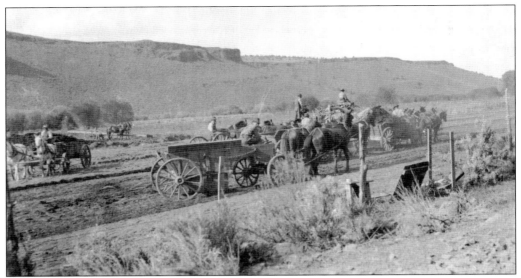

Bonds were issued by the City of Prineville for construction of a railroad in 1916, and actual construction began in 1917. Horse-drawn equipment was used to prepare the grade for the railroad line, which was constructed west along the Crooked River to O'Neil and then up an incline to Prineville Junction.

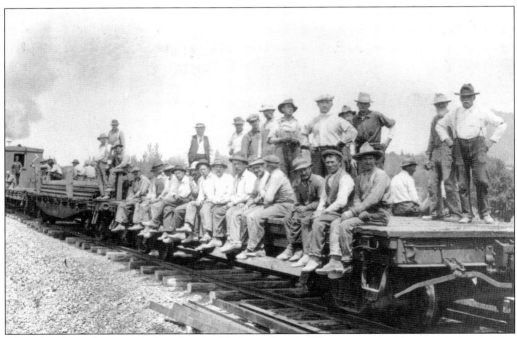

Many local residents were hired to build the railroad. Here a construction gang prepares to move along the line to lay railroad ties and rail iron in this 1917 photograph. The railroad bed was approximately 14 miles long. Because funds were limited, ties were placed on graded ground without gravel surfacing. A number of small bridges were necessary along the Lower Crooked River Valley.

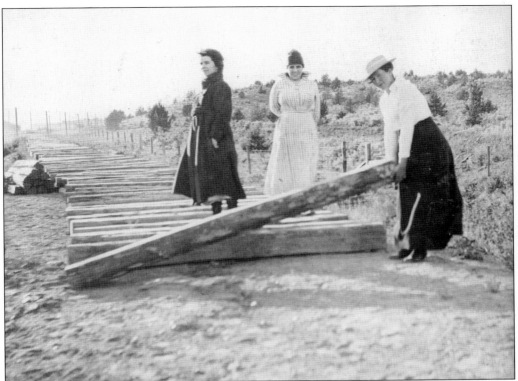

Granddaughters of Monroe Hodges, who platted the town of Prineville, are posing in this 1917 publicity photograph for the construction of the railroad. The young ladies are, from left to right, Dolly Hodges, Stella Hodges, and Vira Cyrus. Note the lack of gravel ballast beneath the railroad ties.

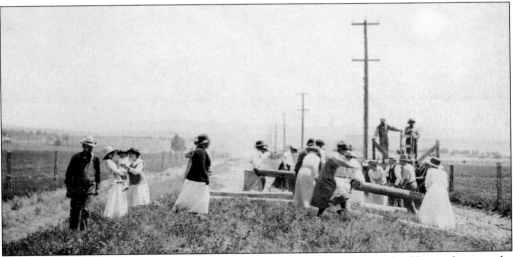

Construction of the railroad was a project of pride for the community, and publicity photographs were taken to show public support for the railroad. This 1917 photograph shows local women helping lay railroad ties in their Sunday clothing. The community anxiously awaited the completion of the railroad for freight and passenger service.

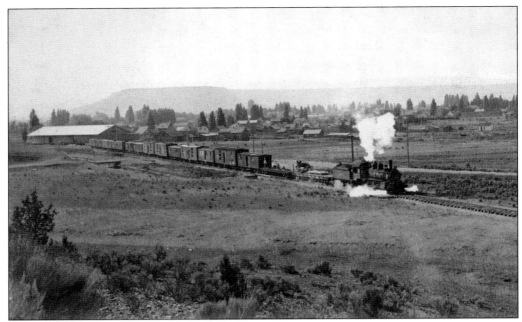

The railroad was completed in 1918 and operations began. It had limited success in the early years because of limited products to ship—lumber mills were not yet established and most freight shipped was livestock or farm produce. There were several derailments in early operations because of the hasty construction, which did not include gravel ballast for the ties and rails. This 1918 view looks southeast from the north end of Prineville.

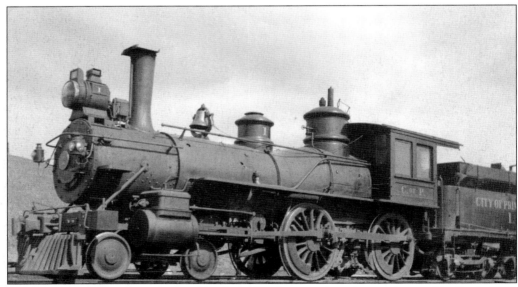

The first steam locomotive purchased by the railroad was used until it was damaged by fire in 1925. At that time, the city purchased an oil-burning Schenectady Mogul locomotive from the Brooks Scanlon Lumber Company of Bend, which had used it for logging. Designated Locomotive No. 2, it was an old engine when purchased but served adequately through the Depression years.

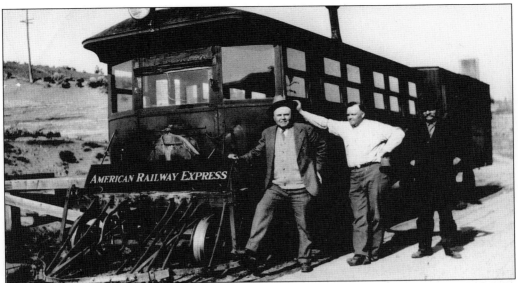

After the original "Galloping Goose" had served out its useful life, another passenger and freight unit was purchased in 1920. Railroad manager C. W. Woodriff is on the left with Frank O'Kelley stretched out behind him. The other man is unidentified. Although this was a secondhand coach, it was better than the "Galloping Goose."

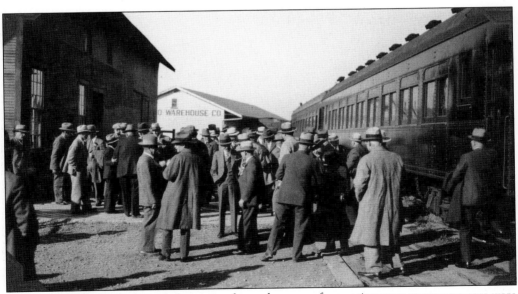

Passenger traffic was relatively heavy in the early years of operation; two passenger cars were operated by the railroad. Freight cars were leased from other railroads. This 1930 photograph shows a busy depot in Prineville. The occasion was a Goodwill Tour of Portland businessmen to Prineville.

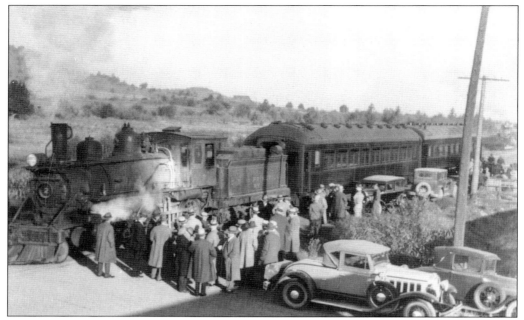

The railroad faced difficult times in the early years. Passenger service was active until the late 1930s but began to decline after expansion of individual ownership of automobiles. This photograph, taken near the Prineville Railroad Depot at Tenth and Main Streets in 1928, shows old Locomotive No. 2 pulling two passenger cars as a crowd gathered.

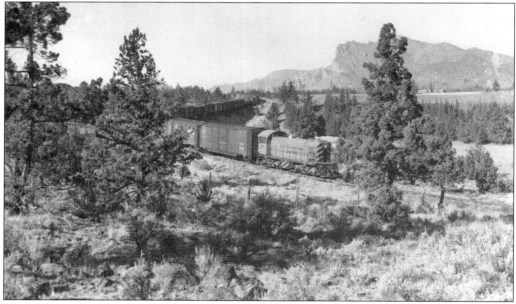

The arrival of lumber mills in Prineville in the mid-1930s led to a boom era for the railroad. After World War II, lumber shipments made the railroad very profitable, with revenues so great that residents paid no city taxes for several years. This view of a modern locomotive on the city-owned line near O'Neil shows Smith Rocks in the background. The decline of the lumber industry in the 1980s led to hard times once again for the railroad.

# Six

# HARD TIMES

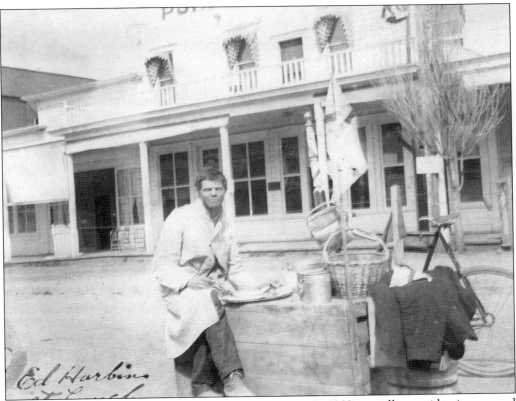

Ed Harbin

Prineville faced challenges similar to most frontier towns. In 1903, a smallpox epidemic occurred when an infected sheepherder became ill while staying at the Poindexter Hotel. Word rapidly spread that he had smallpox, and a short panic resulted. The community soon developed a plan for quarantine and treatment. Here local resident Ed Harbin staffs a smallpox messenger stand in front of the Poindexter Hotel on Main Street.

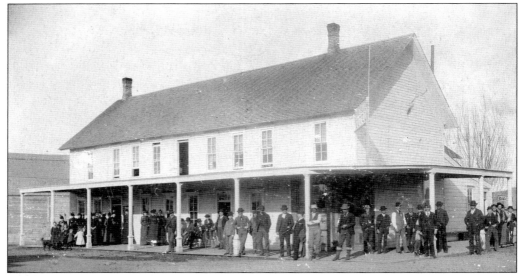

Prineville gained a reputation as a rough town in its early years. In 1882, two men were killed near Grizzly Mountain north of town in a property dispute. The assailant was captured and held in the wooden Prineville Hotel. A group of citizens formed a Committee of Vigilance, took justice into their own hands, and killed the suspect at the hotel. This began the rise of the Vigilantes in the area.

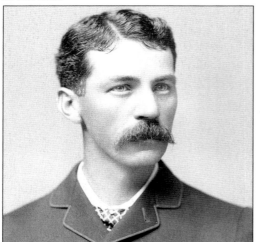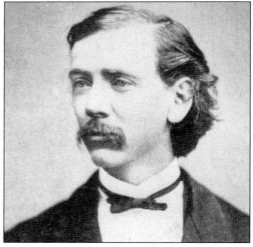

James Blakely (left), a rancher who lived near Willow Creek north of Prineville, helped capture Lucius Langdon, a man who had killed two neighbors in a property dispute. He wanted Langdon to have a fair trial and was outraged when Vigilantes killed the suspect. He opposed the Vigilantes and was part of a group that organized to plot strategies against them. When newly formed Crook County held its first elections in 1884, Blakely was elected the first sheriff, and he vowed to rid the region of the Vigilantes. William Thompson (right) was a prominent rancher that lived on Hay Creek north of Prineville and became active in local affairs. Thompson had been appointed leader of the inquest committees that investigated the deaths attributed to the Vigilantes in 1882, but no one was ever brought to justice for several murders that resulted during that era. After Blakely was elected sheriff, Thompson moved to Northern California. Many years later, Blakely accused Thompson of being the leader of the Vigilantes.

John Luckey was the deputy sheriff for Wasco County in Prineville who was holding Lucius Langdon prisoner in the Prineville Hotel when Luckey was overwhelmed by the Vigilantes and his prisoner killed. He was a prominent early settler and is pictured here in the middle, flanked by brothers Jim (left) and Joe (right).

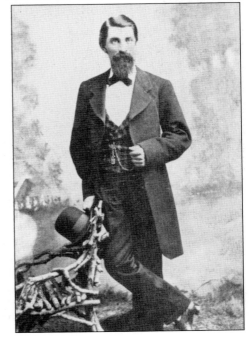

Prineville had as many as seven saloons operating in its early years, and the frontier town was an attraction to adventurers and card players. Hank Vaughn came to town in 1881 with a reputation as a gunfighter. Shortly after his arrival, he got into an argument with Charlie Long in the Singer Saloon, and they settled their dispute with gunshots. Although both were severely wounded, they survived. When they healed they were asked to leave town.

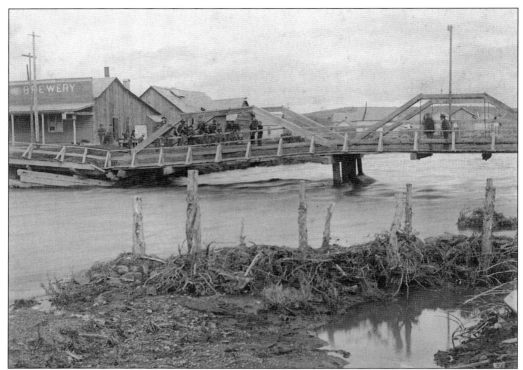

Natural disasters occurred on a regular basis in the frontier community. Flooding of the Ochoco Creek and Crooked River frequently caused residents to flee to higher ground. Ochoco Creek is at flood stage in this pre-1900 photograph on north Main Street. The bridge appears to have some structural damage as a crowd gathers to see the floodwaters.

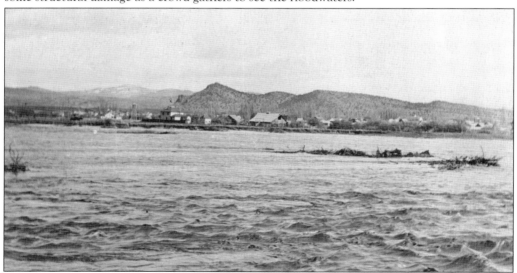

This view of the Crooked River in 1941 shows the valley west of town covered with raging floodwaters. The Crooked River usually flooded every year and would frequently change its course. Diverted by a small dam south of town in 1900, it channeled the water to the west but flooding still was devastating. Flood control was aided by the construction of Prineville Dam in 1965.

This view of Main Street in Prineville shows an early snowfall in 1915. Severe winters often resulted in heavy snowfall in the community and surrounding areas. A severe snowfall in 1889 covered the town with nearly four feet of snow that lasted for several months. It was difficult getting freight and supplies into town as wagon roads were treacherous.

In 1919, the infamous "Blue Snow," named for the deep snow that gave a blue hue to the landscape, fell on Central Oregon. In a 24-hour period, it snowed over three feet and brought wagon travel to a halt. A freeze followed the snowfall, and the snow remained on the ground for several weeks until a warm Chinook wind arrived. The snow was a topic of discussion among locals for many years.

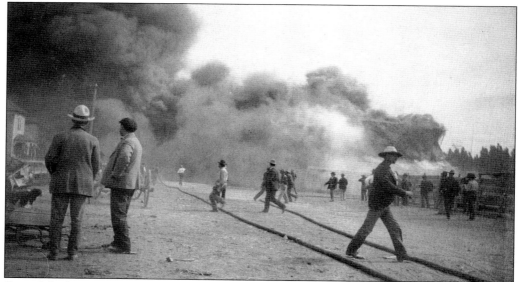

One of the biggest fears of the community was fire. The wooden structures of the frontier town allowed fires to rapidly spread and were frequently disastrous. This 1906 fire resulted in the complete destruction of the Methodist church. Firemen and local citizens frantically try to keep the fire from spreading to other buildings.

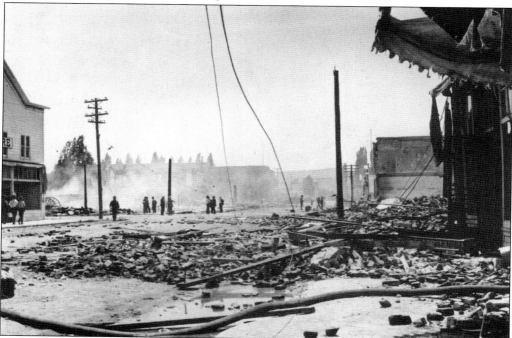

In 1922, a fire raged out of control after starting in the old school building that had been moved to the downtown area for storage. High winds fanned the flames, and nearby buildings became engulfed by the inferno. Half of the business district of was destroyed, including the "fireproof" stone Hotel Prineville. Dynamite was used to blow up some of the buildings to keep the flames from spreading.

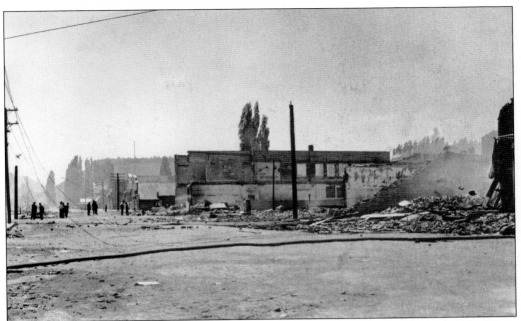

The aftermath of the devastating 1922 fire was felt for many years—over 25 businesses had been destroyed by the fire. The ruins of the Hotel Prineville are visible in this photograph, taken shortly after the fire. A new hotel was built on the same site in 1923 and was known as the Ochoco Inn. Gradually a new downtown business district emerged.

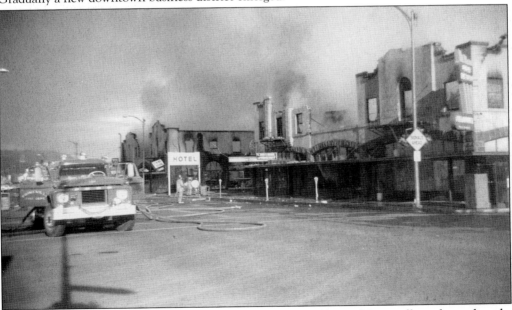

The Ochoco Inn was built in 1923 on the same lot as the old Hotel Prineville and was thought to be a modern "fireproof" building that would avoid the fate of the earlier hotel. It became a famous landmark of Central Oregon. The town managed to avoid another devastating fire for several years. Ironically a fire started in the kitchen grease traps of the Ochoco Inn in 1966 and burned the entire half-block building.

A new grade school being built to replace the three-story brick structure built in 1911 was just nearing completion in 1939, when a devastating fire destroyed the interior of the building, completely gutting it. Only the stonework exterior walls remained standing. Unfortunately the building construction was not fully insured and work was delayed. However, the school was ready for classes to begin in 1940. The building is still being used as part of Crooked River Elementary School.

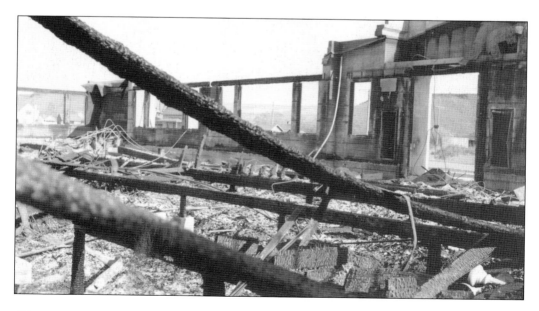

# Seven

# DEVELOPMENT OF INDUSTRY AND UTILITIES

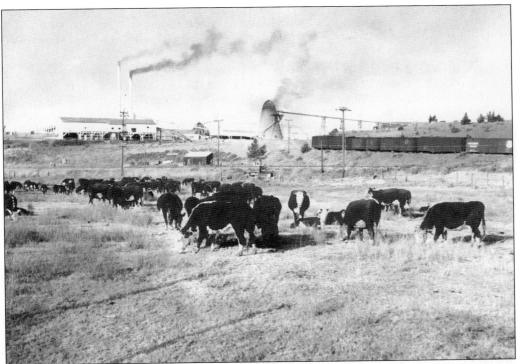

This 1955 image symbolizes the major industries in Prineville at the time. The livestock industry was the initial impetus for settlement in Central Oregon. The cattle in the foreground are at the Prineville Auction yard. Lumber mills were usually small in the early settlement, but by the late 1930s, the lumber industry became the main employer in Prineville, and eventually over five major mills were operating in the community. The Hudspeth sawmill is in the background. The railroad provided transportation for lumber products to larger markets, and the City of Prineville Railroad and boxcars are in the right background.

One of the first major industrial mills to be established in Prineville was the Prineville Flouring Mill, used by local farmers to grind their wheat into flour. James Allen arrived in 1875; constructed the mill, which was located on the south end of Deer Street; and diverted water from the Crooked River into a millrace to provide waterpower to run the mill. Before its construction, the only flour mill in Central Oregon was located on the Warm Springs Indian Reservation. The mill operated for several years.

The dairy industry was among the early enterprises established in Prineville. The earliest known creamery, opened around 1907, was operated as the Prineville Creamery Company. This photograph shows the Ochoco Creamery, located on Main Street between Third and Fourth Streets. Employees are churning butter to sell locally.

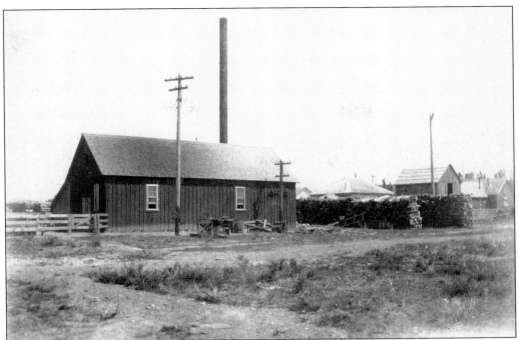

The Prineville Light and Water Company was organized in 1900, and an electric plant was built in Prineville that same year. The boiler and electric plant were shipped by wagon freight from The Dalles. The pioneering system was powered by a 50-horsepower boiler unit that connected to an 18,000-watt dynamo. Electrical service was provided at a flat rate of 5¢ per month per candlepower for lights used until 10:00 p.m. and 6¢ if they burned until midnight.

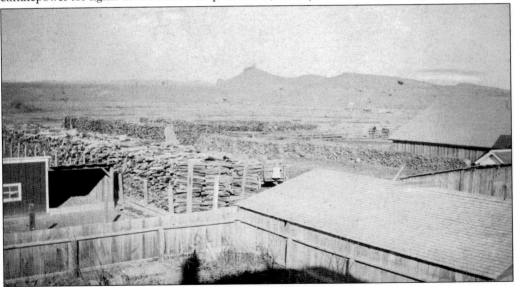

The new power plant required extensive fuel to operate the boilers, and local contractors were hired to cut four-foot length cordwood to supply the boiler. This view shows the extensive wood supply yard at the power plant. The powerhouse installed a small rail system to haul wood to the power-plant yard. Barnes Butte is in the background.

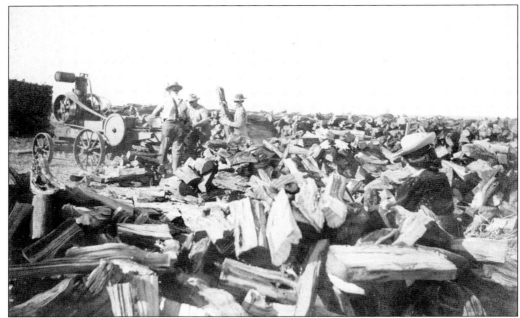

Local contractor Jim Johnson was hired to supply the cordwood, cut into the proper length for use in the boiler by a portable, gasoline-driven cutoff saw, for the power plant. Most of the wood came from juniper trees cut in the area surrounding Prineville. Nearly an acre of ground was used to stack the cordwood as the boiler required plenty of wood to operate. It was nearly a full-time job for the contractor to cut and haul wood to the storage yard. Johnson also operated a small sawmill on Combs Flat and could haul wood to the power-plant site by wagon.

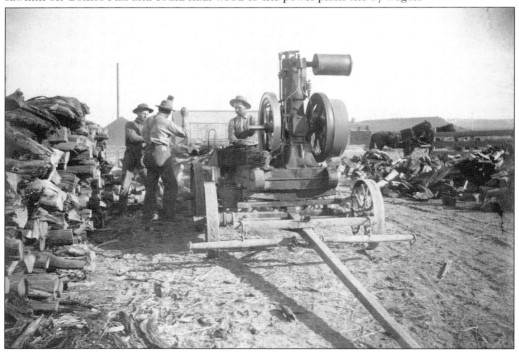

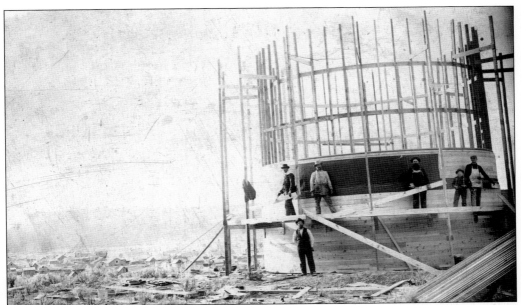

The Prineville Light and Water Company was incorporated on June 11, 1900, and was chartered to provide water and power to the community. Water was pumped from over 12 shallow wells by two duplex Deane pumps to a wooden tank located on a hill just north of the town. The pumps had an operating capacity of 300 gallons per minute. The reservoir tank was a wooden tower structure that was lined to prevent contamination and had a capacity of 25,000 gallons. In the early days, someone had to watch the valve at the reservoir and turn on the pumps when the water level began to get low.

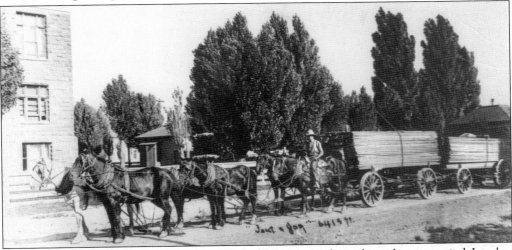

Small sawmills were scattered throughout Central Oregon in the early settlement period. Lumber was mostly produced for constructing homesteads in the immediate area of the mill. Surplus lumber was shipped into town for home and business construction. In this 1916 view, Bill Barney has a load of lumber from the family mill on Mill Creek east of town ready for delivery to the Lippman Lumber Yard. The wagon is on Second Street near the back of the Crook County Courthouse. The humble beginnings of the small sawmills eventually gave way to huge lumber mills that were established in Prineville in the 1930s.

Early logging operations included cutting timber with hand-drawn crosscut saws, as pictured in this photograph. It required two men, but teams became very proficient and could quickly cut down a large ponderosa pine. Crosscut saws were used until two-man power saws were developed in the early 1950s. The large stands of ponderosa pine surrounding Prineville became the object of intense industrial operation after the first major mill was constructed in 1935.

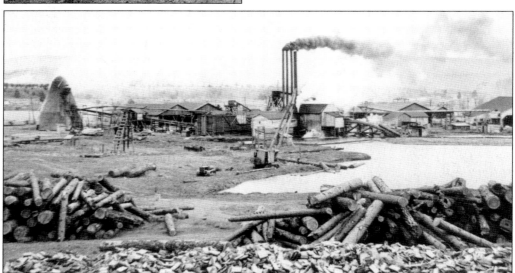

Built in 1925, the first sawmill in Prineville was the Davidson Brothers mill north of town. It ceased operations in 1932 but was reopened in 1935 with the building boom that was occurring across the nation. The new mill, Pine Products, was the first of several major mills to be located in Prineville in the next decade. This 1955 view of Pine Products Mill shows the log pond and main mill.

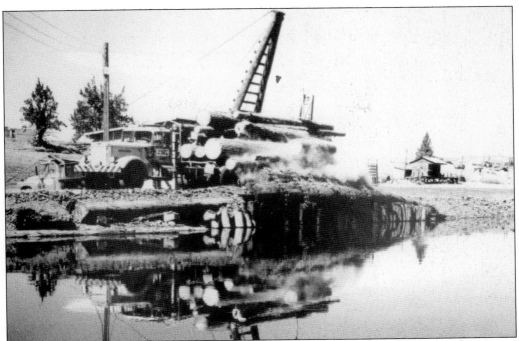

Once mills were established, a logging and transportation system was needed to provide logs to the mills. Logging and trucking firms contracted to provide the logs. In the early years, huge loads of logs were transported from forested areas to the millpond. Logs are being unloaded at the Pine Products Mill pond in this 1958 photograph.

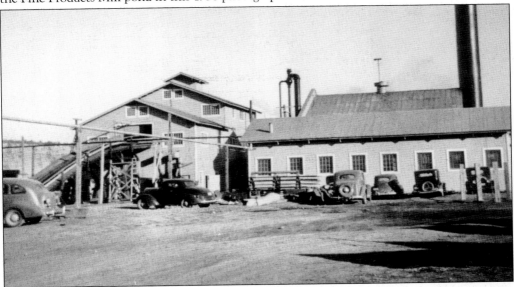

After Pine Products was established, other mills began to have interest in locating in the community because of the plentiful timber supply within transport distance. Ochoco Lumber Company created a mill in Prineville in 1938, and the company had extensive timber holdings southeast of town. The mill produced lumber only, and most of the lumber was shipped to markets in the eastern part of the country. Later lumber was utilized by local wood-remanufacturing plants.

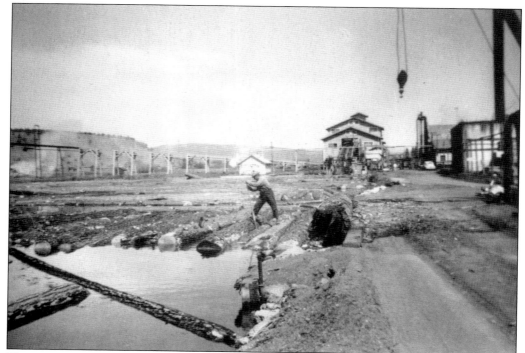

The major mills in the community constructed log ponds to keep cut timber from cracking and to provide a way to easily move logs to conveyor carriages for milling. In this 1960 view, a "pond monkey" is separating logs to send them into the Ochoco Lumber mill for cutting into manufacturing length and for cutting into board lumber.

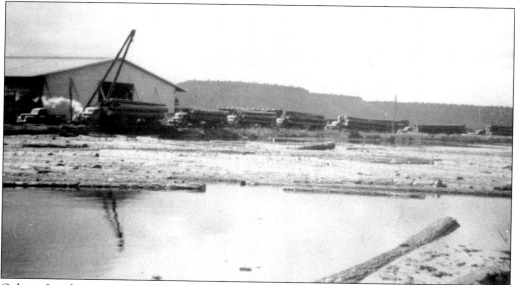

Ochoco Lumber contracted logging and trucking services to Thompson and Van Osten Logging, and extremely large loads of logs were transported over company roads to the mill. Timber extraction was a continuous operation, and several log trucks are lined up in this 1942 photograph waiting to be unloaded at the mill.

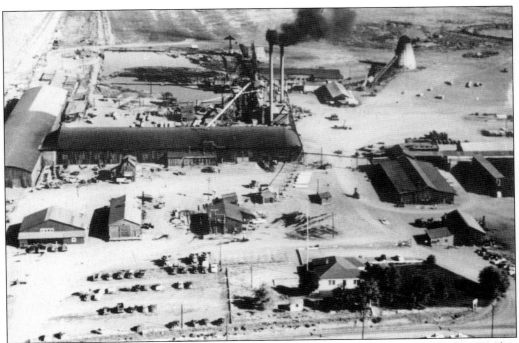

The third major mill to establish operations in Prineville was the Alexander Yawkey Timber Company, a large timber company from Wisconsin that had acquired extensive timber holdings north of Prineville. They first built a sawmill on McKay Creek in 1938 at a location 14 miles north of town. The company also built a dry kiln and planing mill just north of town in 1940. Eventually they moved milling operations into north Prineville. The mill was sold in the early 1950s and operated as Alexander Stewart.

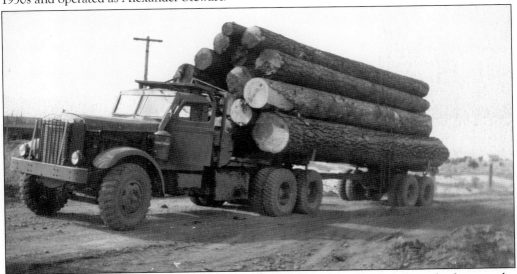

The development of better roads and trucks allowed mills to transport logs from the forest to the mill. Early log trucks were often weighted to load capacity in the days before weight requirements. It was often a challenging moment when other vehicles met the overburdened trucks on narrow country roads. A large load of logs is bound for the Alexander Yawkey Mill in this 1950 view.

The Hudspeth family established a mill east of Mitchell, Oregon, in 1937 and later expanded operations to include a planing mill in Prineville in 1940. Their operation was so successful that they established a major mill in Prineville in 1945. Fred (left), John (center), and Claude Hudspeth were photographed on the opening day of operation for the Hudspeth Pine Mill. The brothers were partners in mill operations, and John later purchased the mill outright.

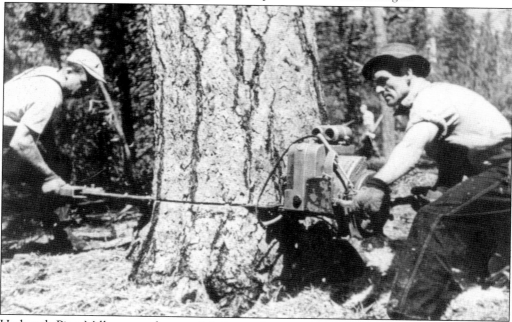

Hudspeth Pine Mill managed most of their own logging operations with some gyppo (contract logging). In this photograph, Casey Bonney and Curly Loop are using a new two-man, gas-operated power saw to cut a large ponderosa pine tree on a Hudspeth timber sale. Logging operations included timber falling, skidding and decking, loading, and hauling.

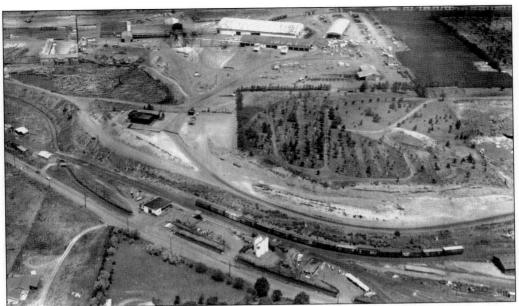

This aerial view of the Hudspeth Pine Mill shows the sprawling operation. The mill and pond are located in the upper left portion of the photograph and the dry kilns, planing mill, and lumber sorting sheds are to upper right. The sawmill burned in 1967 but was rebuilt. Sluggish markets and rising costs led to the closing of the mill in the 1980s.

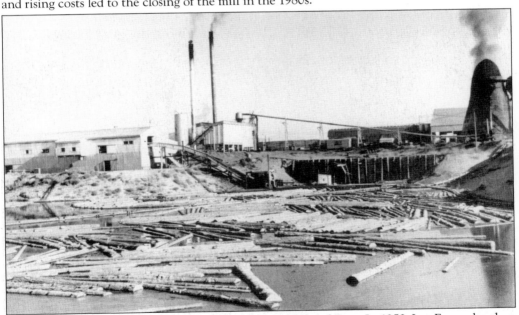

The fifth major mill to locate in Prineville was Consolidated Pine. In 1950, Lee Evans, brother-in-law of John Hudspeth, built a small sawmill along the tracks of the city railroad. The sawmill was eventually bought by John Hudspeth, and he soon sold the mill to Consolidated Pine, Inc., a company from New York. It did not have timber holdings of its own and depended on Forest Service timber sales for logs. It soon diversified to include a lumber-remanufacturing plant. The sawmill ceased operations in the late 1980s.

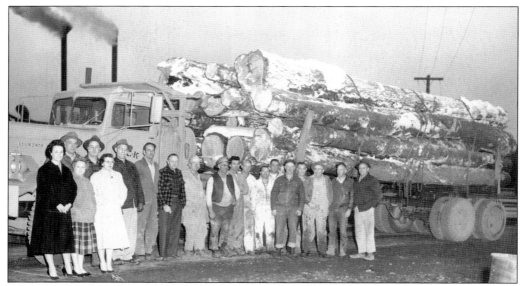

This photograph symbolizes the beginning of the end for the timber industry in Prineville. Five major sawmills had operated on multiple daily shifts to produce extensive pine lumber for a wide market. The mills provided prosperity and jobs, and the community had little unemployment. In 1959, Alexander Stewart announced they were ceasing operations, and the load of logs pictured here was the last to be processed by the mill. The other mills continued to struggle with timber supplies and declining markets, and by 1990, all but Ochoco Lumber ceased to operate. The big-sawmill era came to a close when Ochoco Lumber ceased operation in 2001. Wood remanufacturing plants still operate, but there are no longer any major timber-sawing operations in the community.

An enterprising young entrepreneur purchased the O. K. Rubber Welders store on the east end of town in 1952. The tire and recapping store did a moderate business, but the new owner had much grander ideas about how it could be successful. The man was Les Schwab, and within a few years, the operation became known as Les Schwab Tires. This view is an artistic rendition of the first store.

Les Schwab graduated from Bend High School in 1935. He had worked for the *Bend Bulletin* for many years, beginning as a delivery boy and then moving on to other circulation activities. In 1952, he took a risk and purchased the O. K. Rubber Welders store in Prineville. His innovative ideas and keen marketing ability soon led to an expanding operation. The store became known as Les Schwab Tires and additional stores were added in neighboring communities. The operation became a phenomenon that expanded to include over 400 stores in the West. It is the largest independent tire company in the United States. The Schwab operations include the headquarters office, tire warehouse, and production plant—all of which are located in Prineville—and the company provided many jobs to those who lost theirs when the mill operations ceased.

# ACROSS AMERICA, PEOPLE ARE DISCOVERING SOMETHING WONDERFUL. *THEIR HERITAGE.*

Arcadia Publishing is the leading local history publisher in the United States. With more than 3,000 titles in print and hundreds of new titles released every year, Arcadia has extensive specialized experience chronicling the history of communities and celebrating America's hidden stories, bringing to life the people, places, and events from the past. To discover the history of other communities across the nation, please visit:

## www.arcadiapublishing.com

Customized search tools allow you to find regional history books about the town where you grew up, the cities where your friends and family live, the town where your parents met, or even that retirement spot you've been dreaming about.